KUNSTI
THE COLLECTION IN A NEW LIGHT...

KUNSTHAUS ZÜRICH

—

THE COLLECTION IN A NEW LIGHT

SCHEIDEGGER & SPIESS

Previous page
Passage to the extension

Following spread
View of Heimplatz

CONTENT

COLLECTING.
BUILDING. EXHIBITING:
THE KUNSTHAUS ZÜRICH

The first Kunsthaus was opened on Heimplatz in 1910. It was a house with many rooms, luxuriously appointed, with a huge glass roof and no electric lighting. The citizens of Zurich were taken aback, and wondered if it wasn't a bit on the large side. Since its foundation in 1787, the Künstlergesellschaft had occupied a number of rather modest club premises and then, from the end of the 19th century when it became the Kunstgesellschaft (Art Association), various fairly mediocre exhibition venues. Prior to 1900 there was no collection of any great size, and the organization was of manageable proportions. In around 1890, the board and artists came up with the idea of establishing a permanent location on Heimplatz and marking it with a modern construction. In the architecture competition, the choice fell on Karl Moser who, with his companion Robert Curjel, ran a firm of architects with experience of representative public buildings. Moser's completed design conspicuously advertises the Kunstgesellschaft's main activities: the extended wing was to accommodate exhibitions, while the taller main section would house the collection.

On its exterior, but especially in its interior, the building betrays the influence of the then modern Secessionist movements in Germany and Austria. The highly sophisticated arrangement of the rooms with ample natural light matches the lavish interior decoration, which was restored to its original state when the building underwent a full renovation between 2001 and 2005. Just fifteen years after its inauguration, Karl Moser extended the building to offer more space for the rapidly growing collection of paintings and sculptures, the works on paper and the library. The Moser building became the venue for the activities of the Kunstgesellschaft. Directly adjacent to it is the late-historicist Schauspielhaus, which has served as the city's principal theatre since the 1920s and also plays a role in the future architectural development of the site. Heimplatz is becoming an urban centre for the arts.

As the number of exhibitions grew, so the international contacts deepened, supported by a number of artists and the first director of the young institution, Wilhelm Wartmann (1882–1970). During the 1920s and 1930s, meanwhile, also the collection continued to grow, with purchases of works by contemporary artists including Edvard Munch and Pablo Picasso. There is scarcely a prominent name missing from the list of exhibitions since then, and the artworks on show in them have often been purchased for the collection.

The Kunsthaus was not enlarged again until the 1950s, under the directorship of René Wehrli, when it acquired an exhibition wing designed in 1944 by the brothers Otto and Werner Pfister and funded by the industrialist Emil Bührle. Bührle's patronage, his presence on the committees of the Zürcher Kunstgesellschaft, and his art collection all had a role to play. With an exhibition gallery measuring 1,200 square metres, the Kunsthaus was now equipped to address a wider audience and further expand its exhibition programme. The Pfister brothers redesigned the entrance area of the Moser building, opening it up to a courtyard landscaped with greenery and laying the characteristic light-coloured marble floor that extends onto the forecourt and links the interior visually with the square.

A further enlargement followed in the 1970s, with an annexe designed by the Zurich architect Erwin Müller in which a number of floors are connected by a central staircase. Although the construction's somewhat Brutalist appearance and fit-out have made it less popular than the more elegant Moser building, it is nevertheless characteristic of the fundamental changes that the museum as an institution underwent in the late 20th century, offering generous proportions and openness, uniform illumination with plenty of natural light, and the spatial connection (now lost) between the interior and a green outdoor area. These qualities would continue to influence the development of the museum architecture in the decades that followed.

Unlike other comparable museums, the Kunsthaus furnished its Collection of Prints and Drawings and the extensive Kunstgesellschaft library with their own dedicated rooms as well as a reading and study room. When the complex underwent a comprehensive refurbishment beginning in 2002, the two areas were separated from each other and enlarged, and each now has its own entrance. Following the purchase and sensitive renovation of the historic Villa Tobler on Winkelwiese, the director's office and administration moved from the cramped confines of the Moser building's ground floor, freeing up space for an initial reconfigured presentation of the holdings of the Alberto Giacometti Foundation. This investment in improved presentation facilities, the new entrance layout along with the technical upgrade and a restoration of the building complex that befitted its historic monument status, were all to bear fruit.

The concept phase for the next enlargement was launched in 2001, with a public symposium on the international development of museums. The first, already detailed concept was drawn up with an eye to previous experience, and especially the changing relationship between art and its audience. There was to be extra space for encounters with art, for contemporary forms, and for cooperations with foundations and private collections, paving the way for the museum to move into the 21st century.

An in-depth feasibility study concluded that the future location of an extension on Heimplatz, directly adjacent to the existing complex, was essential to the efficient operation of the enlarged institution. Two gymnasia that were still in use were successfully removed from the inventory of listed buildings and, after much local debate, demolished in order to make room for the project. Thanks to intensive advance planning, the criteria for the international architecture competition had already been defined in detail. The key elements were the new building's presence within the urban landscape, and the linking of Heimplatz to the north site via a newly created park in front of the former cantonal school, a well-proportioned building by the architect Gustav Wegmann dating from 1839.

The competition was won in 2008 by the British architect David Chipperfield. His design met the ambitious requirements and incorporated the necessary urban planning solution. The clear cubic form of the building is ultimately a product of the Kunsthaus's sophisticated use concept, with great importance accorded to the arrangement of the rooms inside and the intricacies of the interior design. The architect and his team learned much from the existing buildings, and transferred their findings to the new project.

The popular vote on the fully elaborated construction project held in the city of Zurich in 2012 included a financing plan allowing for total construction costs of 206 million Swiss francs: 88 million from taxes, 30 million from the lottery fund and the site from the Canton of Zurich, as well as a further 88 million from a fundraising campaign run by the Kunstgesellschaft. A detailed business plan contained projections of future operations, and the follow-up costs were calculated, so that the increased subsidy could also be put before the electorate. A five-year plan which is continually updated allows for precise financial forecasts and enhances planning certainty.

The start of construction was delayed for two years by an appeal against the grant of the building permit. Once the foundation stone was laid in winter

2015, the work of building commenced, involving hundreds of builders, crafts-people, the construction authority and project managements liaising closely with representatives of the Kunsthaus, in accordance with the museum's concept and the architect's further developed plans. Around three-quarters of the rooms are illuminated by natural light. A passage between the buildings, for which Olafur Eliasson has realized a striking commission, guarantees the safety and security of both visitors and art. Extensive spaces are available for art education and there are prestigious rooms for events, including the elegant, multifunctional ballroom. The entire construction meets the latest environmental standards.

Naturally, a spatial enlargement of this magnitude goes hand in hand with a marked improvement in the quality of the holdings. One of the principal strategic objectives was, and remains, to bring in private collections. A number of these had been secured for the Kunsthaus on a long-term basis as far back as the 19th and mid-20th centuries, and as a result the museum has the most important assembly of Old Master paintings with a distinct profile anywhere in Switzerland, save for the Kunstmuseum Basel. Although Swiss museums can hardly compete with the institutions that arose out of former princely collections, Switzerland has a long tradition of collecting this era of art history.

The most recent addition to the Old Master holdings came with the collection of Ferdinand Knecht, comprising some forty paintings by Dutch masters in cabinet format, including works of outstanding quality. They are a perfect fit for the foundations of Leopold Ruzicka and David Koetser, which arrived at the Kunsthaus in the late 1940s and the 1980s, respectively. Recent targeted acquisitions of Old Masters have been paid for using funds from the Dr Joseph Scholz Foundation. The Kunsthaus's now world-famous Dada collection and exceptional holdings of painting and sculpture from the 1980s and 1990s were assembled under the directorship of Felix Baumann.

The phenomenal breadth of the collection of works by Alberto Giacometti, made possible by the Alberto Giacometti Foundation, is further enhanced by the approximately 200 works bequeathed by Bruno Giacometti (1907–2012). In consequence, Zurich is now home to the largest public collection of the artist's oeuvre, which can finally be presented on a much larger scale and, for the first time, in dialogue with the art of Classical Modernism and the post-war era. Of particular note is the donation of the exceptionally multifaceted Beuys collection put together by Baronessa Lucrezia De

Domizio Durini and her late husband. They complement the artist's celebrated and seminal sculptural work *Olivestone* (1984), which was acquired by the Kunsthaus through the intercession of Harald Szeemann and is now displayed in a new setting.

The plans for the extension allowed for cooperations with private collections and foundations as well as numerous gifts of individual works and groups, making what is probably the most substantial contribution to the enlarged Kunsthaus. A far from insignificant gap in the collection concerns American art of the 1960s and 1970s, although a small number of key works are on permanent display. One of the few collectors in Europe to study and acquire outstanding works from that era is the entrepreneur and patron of the arts Hubert Looser. A precise selection from his collection has been secured for the long term, combined with a forward-looking agreement that allows for the works from the Looser Collection to be displayed in dialogue with the Kunsthaus Collection.

In international terms, the Merzbacher Collection is of particular status among Swiss private collections thanks to its artistic quality. It brings with it some seventy pivotal works of German Expressionism and French Fauvism that Werner and Gabriele Merzbacher accumulated over more than five decades, with a combination of passion and connoisseurship. The brightly coloured paintings will fill an entire room as a permanent 'feast of colour', complemented by Pipilotti Rist's installation *Turicum Pixel Forest* (2021).

A central pillar of the extension plan from the outset envisaged the Foundation E. G. Bührle Collection moving to the Kunsthaus. Part of this exceptionally valuable ensemble, put together by the industrialist, patron and collector in Zurich between 1936 and 1956, was exhibited in a private villa in an outer district of the city from 1960 onwards. Its main focus is on 19th-century French art, with other groups including Old Master paintings, medieval sculptures and Classical Modernism. Few collections have been so thoroughly researched and published as that of Emil Bührle. A dossier of materials compiled by the Kunsthaus and housed in one of the collection galleries documents Bührle's biography, the genesis of his collection, the links to the Zürcher Kunstgesellschaft, and the issues of looted and flight art. The masterpieces by Manet, Cézanne, van Gogh and Monet perfectly complement the already rich collection of the Kunsthaus, making for the largest gathering of Impressionist works anywhere in Europe outside Paris. A deliberate decision was taken that the collection of Emil Bührle should be on public display, and that the Kunsthaus is the right place for it. In the context of the

Kunsthaus's own holdings and the foundations and donations that have shaped our institution for more than a century, this exceptional collection is of pivotal importance.

Private art collectors have demonstrated exceptionally enduring trust in the Kunsthaus Zürich over many generations. Few other institutions in Europe have been, and continue to be, so copiously endowed, offering the public a chance to benefit directly from the discreet generosity of patrons of the arts. One outstanding example is the most recent and valuable donation of a work that the Kunsthaus had sought to acquire for longer than any other: a major piece by Gerhard Richter which came to the Kunsthaus via the Kunstfreunde Zürich shortly before the opening of the Chipperfield building. The Kunstfreunde, who have been supporting purchases of artworks for more than a century, regularly enhance the quality of the collection through acquisitions proposed by the Kunsthaus.

The Kunsthaus thus combines a variety of cooperation models that are aligned with the foundations' own regulations during sometimes protracted but fruitful negotiations, and matched to the Kunsthaus's conceptual ambitions. The future will see further collections and individual works enter our institution, some as bequests already promised, others as long-term loans for which agreements have already been reached. Naturally, the Kunstgesellschaft's collection also evolves year by year, in line with the funding available. The Kunsthaus Collection has always been, and remains, extremely heterogeneous, owing to the specific circumstances of its evolution as an 'association's collection'. It does not offer a complete survey of art history and the succession of styles, but it covers certain areas with works of very high quality and spans a chronology extending from the Middle Ages to the present day.

During the planning phase and right up until completion – a period of more than a decade and a half – the Kunsthaus has been preparing for the biggest enlargement in its history. The collection has been expanded with an eye to the extra space and larger rooms available, and new acquisitions have thus included large-format paintings and installations. Particular attention has been paid to one area: contemporary art. Here, the Kunsthaus has always cherished its independence, which it continues to maintain. Given that the existing holdings tend to be weighted towards Western art, specific efforts have been made to embrace key aspects of non-European art – focusing, for example, on the Middle Eastern cultural sphere. Greater emphasis is also being placed on acquiring and exhibiting the work of contemporary female artists.

Acquisitions and exhibitions go hand in hand. The Kunsthaus Zürich has successfully maintained its international status for decades, thanks to its wide-ranging exhibition programme, and temporary presentations have been a central element of its public face from the very start. Hundreds of exhibitions have been held at Heimplatz since 1910, and there is scarcely an artistic name that has not been displayed prominently at least once, leaving its mark on the collection in the process. The list is a long one, and extends from Ferdinand Hodler, Edvard Munch, Pablo Picasso, Georg Baselitz, Sigmar Polke, Katharina Fritsch, Georgia O'Keeffe, Urs Fischer and Cindy Sherman to Olafur Eliasson and Gerhard Richter, not to mention the many contemporary artists in group exhibitions held at the Kunsthaus; there are also regular, large-scale presentations of French art. One particular feature is the thematic exhibitions, with a spectrum ranging from the 1950s to legendary major projects in the 1970s and 1980s, and on to striking, ground-breaking projects extending into the present day, many of which are shown at other museums abroad. The Kunsthaus does not shy away from less accessible topics: absolute visitor numbers have always been a relevant criterion, but never the sole one. Thus, the original idea of a largely autonomous exhibition institution with a collection attached has matured over the space of around a century into a fully fledged museum.

The expanded Kunsthaus offers far more space for new forms of presentation and public involvement. In terms of that specific interaction, the way in which the collection is presented has changed. Mute contemplation has given way to active participation. Movement, dialogue and discussion have become an established part of how museums operate and present themselves to the outside world. New media are coming to the fore, and the recently created Kunsthaus Digilab, an educational tool for virtual forms of expression and artworks, is being continually refined. At the same time, conventional forms of art education are being progressively expanded, with fringe events, round-table discussions and symposia complementing an extensive programme of guided tours. The audioguide has grown to cover more than 400 subjects in a variety of languages and now offers information on topics ranging from architecture and interior design to the institution's history and art technology. The rooms of the Kunsthaus have around 150 wall texts

imparting all manner of information. The collection is progressively going online, its history is being explored in greater detail, and provenance research is conducted intensively and transparently. Thanks to the dedication of its staff and its sound financial base, the Kunsthaus Zürich is seen as a valued and trustworthy partner around the world. The enhancement to Zurich's museum landscape represented by the Chipperfield building sends a clear signal and is a major step into the future. The spacious, light-filled and elegant construction is testimony to the precise planning in which every member of staff was involved right down to the last detail; but above all it bears the signature of an outstanding architect with a profound understanding of the museum as institution and extensive experience in museum building. Sir David Chipperfield and his team of architects in Berlin have responded brilliantly to the challenge of creating the Kunsthaus extension.

This book presents the ideas and their implementation against the backdrop of our history, the extension and the demands of the present day, and makes them visible. The story of the Kunsthaus Zürich and its development into an institution of European importance is both symptomatic and, in retrospect, more successful than that of almost any other museum internationally: the Kunsthaus has grown and evolved. That process is not complete. It has gained extra momentum. In that sense, the Kunsthaus extension by Sir David Chipperfield is not the end of a story, but the start of a new one.

I should like to express my sincere personal gratitude to the many people who have worked on our joint project with vision, determination and commitment – and continue to do so. This book is dedicated to them. We hope it will inspire you to look at, experience and understand art and this museum. Our thanks go to all our visitors for their interest in the Kunsthaus Zürich, both now and in the future.

Christoph Becker

Following spread
Staircase in the Moser building with, among others, works by Ferdinand Hodler, Augusto Giacometti, Cuno Amiet and Auguste Rodin

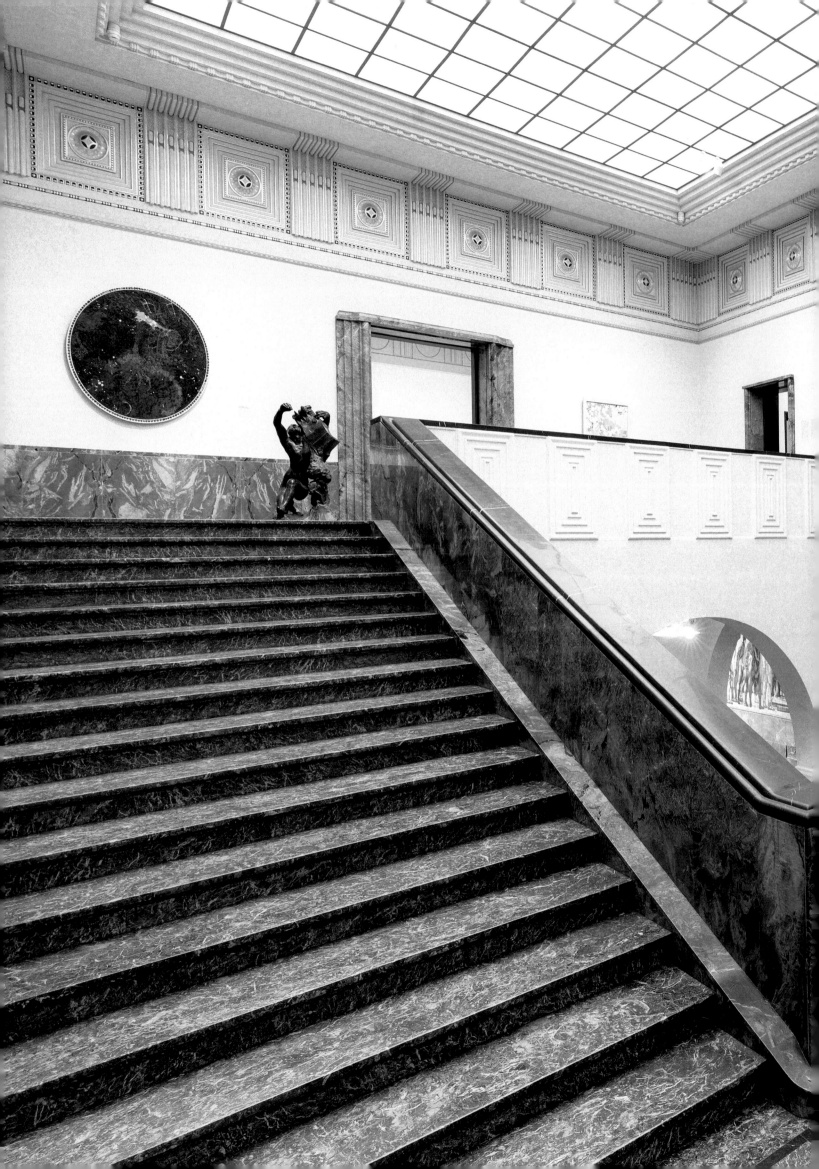

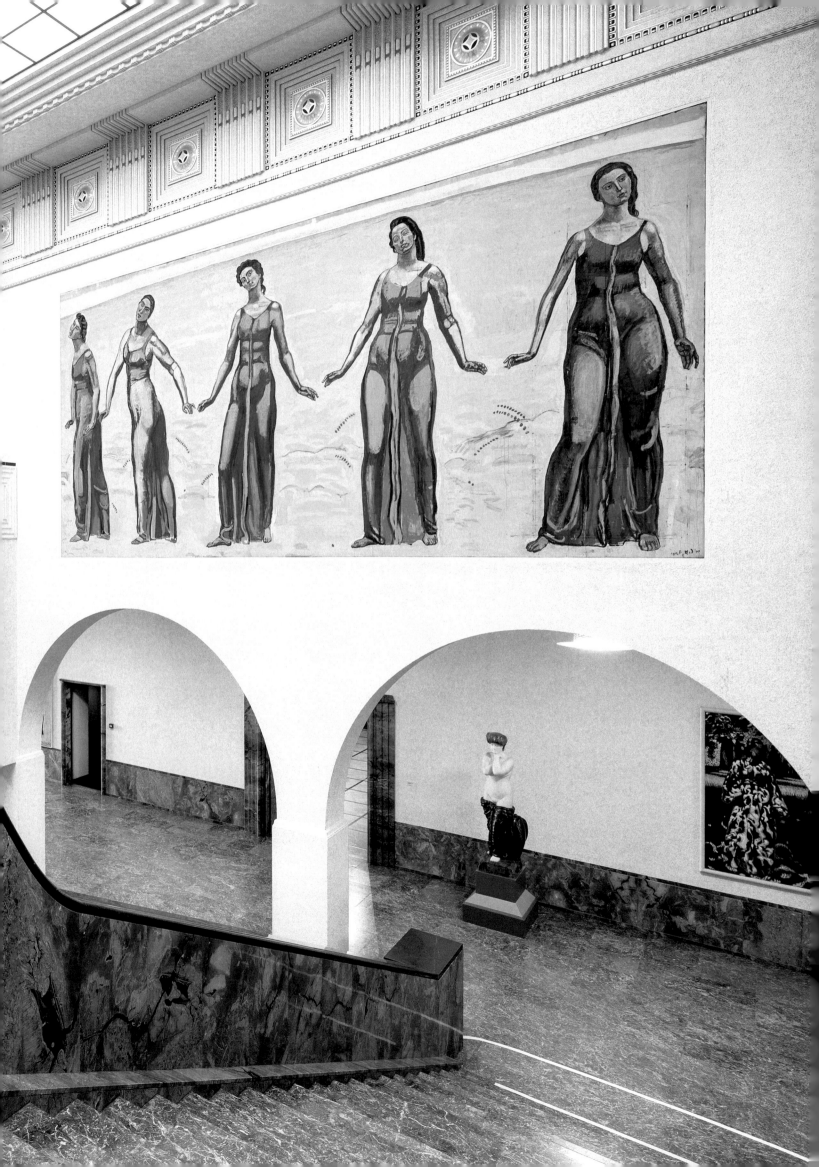

THE COLLECTION: THEMES, CONTRASTS, NARRATIVES

The opening of the extension by Sir David Chipperfield marks the start of a new era for the Kunsthaus Zürich. Never before has there been so much space to show art. It was clear from the outset that the collection should be one of the major beneficiaries of the expanded and improved facilities.

The collection started out small, in the late 18th century, and it was not until 1910 that it moved into what could truly be called a museum on Heimplatz: the Jugendstil building designed by Karl Moser who expanded it in the modernist style by 1925. It was there that temporary exhibitions were held until the exhibition wing designed by the Pfister brothers and funded by Emil Bührle was added in 1958. The open-structured building by Erwin Müller, inaugurated in 1976, at last offered more space for the collection. Now, the distinguished building by Sir David Chipperfield stands ready on the other side of Heimplatz. Yet, like the original Moser building, it will not be given over entirely to the collection.

The goal, then, was to put this complex assembly to the best possible use for the collection, placing the works in the right rooms in the buildings most suited to them. The concept adopted for the new collection presentation was informed by a particular feature of the Kunsthaus: since the Moser building opened, the collection has thrived on being displayed alongside works that are not owned by the Zürcher Kunstgesellschaft (Art Association). Since 1917, they have included items made available from the extensive collection of the Kunstfreunde Zürich (VZK). For many years, the City and the Canton of Zurich have also deposited certain key works from their collections at the Kunsthaus, while the world-ranking holdings of the Alberto Giacometti Foundation have mostly been kept here on long-term loan since it was established in 1965. Other long-term guests include the important Old Master paintings in the Koetser Foundation, which have resided at the Kunsthaus since 1986. They are further enriched by loans from private collections, such as the Walter A. Bechtler Foundation.

When we refer below to the 'Kunsthaus Collection', we are also including those holdings, so that the term covers all the works kept here long-term or permanently and typically displayed together. This wide range of ownership has always been a characteristic feature of the exhibition galleries at the Kunsthaus – as has the constantly reinvented entity fashioned from them.

A new model: private collections presented separately

This model changes markedly, however, with the opening of the expanded Kunsthaus. The reason is the integration of four major private collections, a process which concludes with the inauguration of the new building. They are the **Knecht Collection**, comprising some forty-five works of 17th-century Dutch and Flemish painting; the **Emil Bührle Collection** of around 180 Impressionists, Early Modernist works and Old Masters; the **Merzbacher Collection**, with approximately seventy-five works of mainly Expressionism and Fauvism; and the **Looser Collection**, containing around seventy works of Abstract Expressionism, Minimal Art and Arte Povera.

The integration of these collections is both the continuation of a tradition at the Kunsthaus and a unique enhancement to it. At the same time, it permanently changes the structure of the holdings on display: for the opening presentation, the collections are not being shown with matching holdings from the Kunsthaus, but rather in separate rooms specifically assigned to them. The Knecht Collection, which entered the Kunsthaus in 2016, could in theory form part of a joint presentation, and indeed this has already been done with great success. Over the medium term, it is also explicitly planned that works from the Kunsthaus will be temporarily displayed from time to time in the rooms set aside for the Looser Collection. The Bührle Collection and Merzbacher Collection, however, are to be shown monolithically as discrete entities, in accordance with the wishes of those responsible. The only exception is Claude Monet's large *Water Lilies*, where works from the two different collections – the Emil Bührle Collection and the Kunsthaus Collection – are shown together.

With the opening of the extension, the activities of private collectors receive greater prominence than ever before at the Kunsthaus. Private collecting is emphasized as an activity clearly distinct from the acquisition policy of a museum. The essence and particular characteristics of these two different forms of collecting are shown in all their contrasts, enabling them to be studied next to each other in the museum context.

Moser building,
room housing
the Knecht Collection

Chipperfield building,
large room of the
Emil Bührle Collection

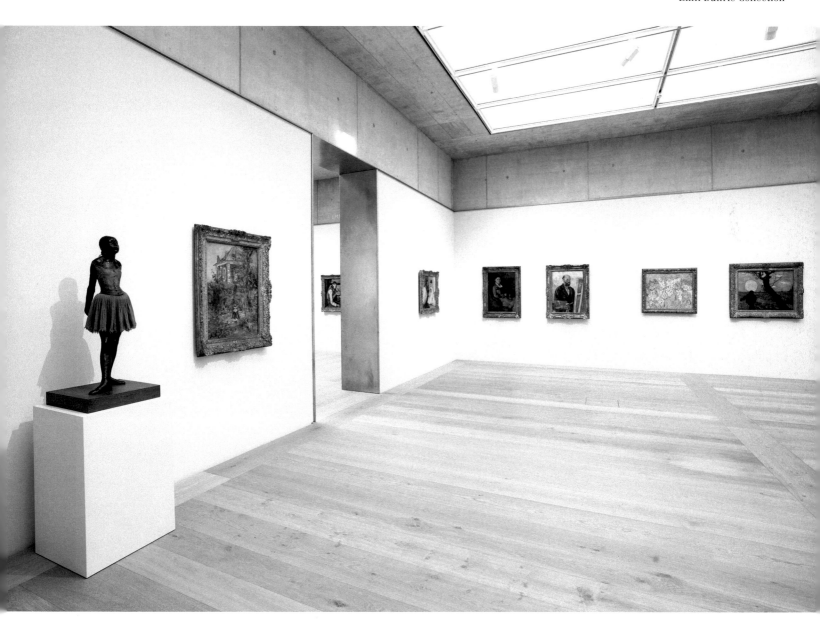

Chipperfield building,
room housing the
Gabriele and Werner
Merzbacher Collection,
works by Henri Matisse
and André Derain

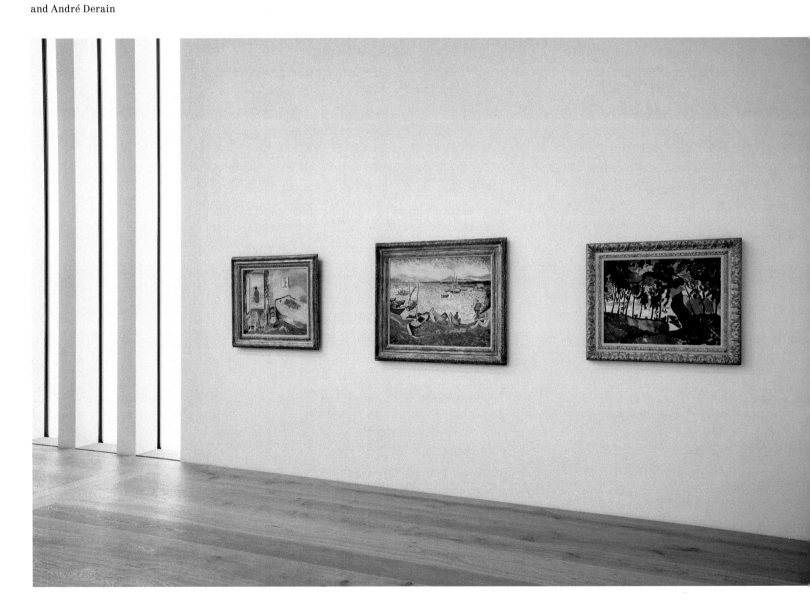

Chipperfield building,
large hall with a work
by Ellsworth Kelly
from the Hubert Looser
Collection

The Chipperfield building: a magnet for art

It was evident even before the popular vote on the new construction that the Emil Bührle Collection would be shown in the extension; indeed, its inclusion was a central argument in the case for the new building. It was likewise agreed from the outset that the Merzbacher and Looser collections would be displayed there. The only exception was the Knecht Collection, which was assigned a place in the Moser building so that it could be shown in direct proximity to the Kunsthaus's classical Old Master galleries.

In all, the already existing buildings offer 6,480 m² of exhibition space. The extension has 5,040 m². There are 4,960 m² in the existing buildings set aside for holdings on permanent display (including 68 m² for the Knecht Collection) and 1,520 m² for temporary exhibitions. In the extension, the figures are 4,330 m² for works from collections (with 2,260 m² for the Bührle, Merzbacher and Looser collections) and 710 m² for exhibitions.

That leaves around 2,070 m² in the extension for the Kunsthaus Collection (this time excluding the newly arrived long-term loans), compared with around 4,900 m² in the existing buildings. Altogether, less than one-third of the Kunsthaus's own holdings are in the extension, so the existing buildings will remain the principal locations for them. It was therefore crucial to plan carefully which works would find a place in the attractive new structure.

The rationale behind the arrangement

The decades of experience working with the Moser and Müller buildings played a key role when deciding how to arrange the Kunsthaus Collection in the new complex. The constant need to accommodate the significant differences between the sections dating from 1910/1925 and 1976 had encouraged the development of strategies that could handle those stark distinctions. In particular, it meant that any attempt to arrange the holdings in chronological order throughout would not work as an underlying structure. That circumstance is accentuated still further by the arrival of the Chipperfield building. While the new construction mediates perfectly between the buildings on Heimplatz, unlike the existing structures in which visitors can circulate freely through the rooms, the Chipperfield building is a discrete entity. As a result, there are now two distinct breaks in continuity to deal with when deciding how to organize the exhibits.

It therefore seemed expedient to keep the chronology of artistic development in mind but, as far as possible, to display the individual holdings where they work best, and where they are supported by the architectural context. Groups of works were identified that constitute entities in their own right – 'clusters', as we refer to them – and these were allocated to the rooms best suited to them.

In this concept, the individual clusters (acting as narrative units in a kind of 'storytelling') function autonomously; they can – but need not – adjoin other clusters that are thematically or stylistically related to them. This sets up contrasts between individual clusters and encounters between divergent contexts that encourage new ways of seeing. That is the basis of the new overall presentation.

This approach is especially evident in the 'intervention spaces': defined rooms in the existing buildings and the extension that, unlike those containing settled and enduring ensembles from the collection, regularly play host to new exhibits. They are designed as abrupt departures from the content of the adjoining rooms that will invigorate the classic, canonical holdings with art that is new, very often female, and not infrequently controversial.

The Moser building

The Moser building, with its traditional architectural style and well-structured rhythm of rooms of varying size, has established itself as a fine place to exhibit art from the Old Masters to the Early Modern era. Only certain sections are suited to more recent art: areas with a carpeted floor, for example, are not suitable for contemporary installations.

The first floor is home to the Old Masters – arranged by era, style or theme – and the Knecht Collection. There is a group of rooms devoted to the Swiss masters of the 19th century: Albert Anker, Rudolf Koller and Robert Zünd, Albert Welti and the Symbolist Ferdinand Hodler. A room housing works by Arnold Böcklin adjoins another displaying the metaphysical painting of Giorgio de Chirico, where Böcklin's influence is evident. For the opening presentation, an intervention space in the central domed room makes a statement of intent, bringing together a work by Anna Boghiguian and another by Kader Attia. This room radiates thematically outwards into the adjoining Old Master gallery and, with it, makes up a further cluster (see p. 43).

The narrow room conceived by Karl Moser as a sculpture gallery now forming a passage through to the Müller building presents a dazzling array of important sculptures by Henri Matisse, Henri Laurens, Constantin Brancusi, Jacques Lipchitz and Alexander Calder. Forming a stylistic counterpoint within it are Neoplasticist paintings by De Stijl. This room, which covers the development of modern sculpture in Paris, makes up another large cluster with the adjoining area of the Müller building devoted to the works of Alberto Giacometti.

On the second floor is the large, imposing room on Henry Fuseli and Romanticism in Germany and Switzerland (see p. 34–35), which

leads on to French Romanticism, the Realism of Gustave Courbet and early Impressionism. This section concludes with Édouard Manet's *Rochefort's Escape* (1880/81), a key work in which the waning genre of history painting morphs into pure painting in the depiction of the sea. The Nabis are well represented, with works by Édouard Vuillard, Pierre Bonnard and Félix Vallotton. Along with them is a canvas by Paul Gauguin from his time in Brittany, which was a major influence on the Nabis. The section leading through to the Müller building is home to another cluster on war, art and provenances (see the essay in this book, pp. 70–77), with works by Edvard Munch and his admirer Georg Baselitz paving the way for more recent art, as well as an intervention space on the theme of provenance.

On the ground floor, in the intimate spaces surrounding the cabinet, works by Marc Chagall, Paul Klee, Franz Marc, Wassily Kandinsky and others, Swiss figurative art from 1910 to 1950 and the Zurich Concretists bring together various important names in Classical Modernism who were not chiefly active in Paris.

The Müller building

Mainly used since its inception for works from modernism through to the present day, the Müller building has an open structure that is not always easy to exploit effectively. It has been extensively reconfigured, and many of the subsequent additions to the interior have now been removed. The ground floor is conceived as an open space for presenting new art of varying character. Here, too, a number of clusters have been created.

The large-scale presentation of the important Alberto Giacometti holdings on the first floor (see pp. 55–57) meets works by artists who influenced him, were connected with him, or were active during the same period, chiefly in Paris. A dense tableau showing the development of key strands in modern art from 1900 to 1965 thus builds around the Giacomettis. Works by Francis Bacon and, finally, Rebecca Warren created after Giacometti's death complement the selection.

The mezzanine brings works of Nouveau Réalisme by Jean Tinguely together with British and American Pop Art, and more recent creations by Sylvie Fleury and Abraham Cruzvillegas, both of whom have updated elements of Pop Art for a present-day audience (see pp. 62 and 63).

On the top floor, the focus then shifts to Minimal Art. A large room stripped of extraneous elements is dominated by Bruce Nauman's majestically laconic ring of plaster called *Model for Tunnel. Square to Triangle* (1981), accompanied by the works of Jenny Holzer and Anna Winteler. Moving on into the Moser building, visitors are welcomed by vast exhibits that also date from the 1980s but employ an entirely different technique, in the form of major works by Georg Baselitz. Here, as on the first floor, there is thus a link between the Moser and Müller buildings.

Müller building,
works by Francis Bacon
and Rebecca Warren

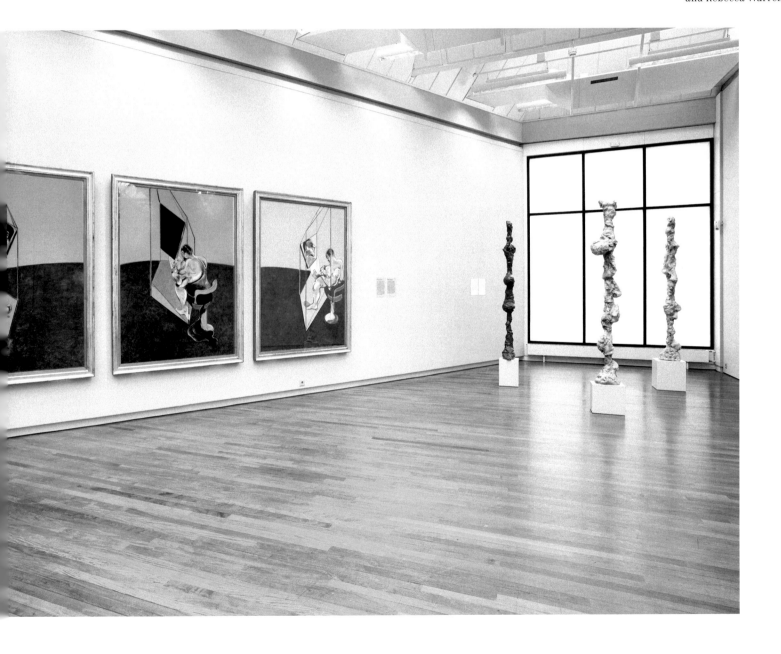

The Chipperfield building

The exhibits chosen for the extension are thematically rich and complex. They include works from the late Middle Ages and Old Masters from the Emil Bührle Collection, right through to contemporary art. The long-term loans from the Bührle Collection on the second floor and the Merzbacher and Looser collections on the first exert a powerful presence. In all, they occupy more than half of the area set aside for the Kunsthaus Collection.

Once it was decided that the Emil Bührle Collection would find a new home in the Chipperfield building, the next logical step was to locate the Impressionists and Post-Impressionists from the Kunsthaus's own holdings in this suite of rooms, along with Monet's *Water Lilies*. That in turn led to the creation of a room containing key works of Parisian modernism from the circle around Pablo Picasso. In particular, this highlights the historically important axis that runs from Paul Cézanne to the Cubists and Fernand Léger. Combined with the corresponding works from the Emil Bührle Collection, the result is an important and wide-ranging cluster on art in Paris and France from 1870 to the Second World War. The last room in this section is devoted primarily to the landscapes of Ferdinand Hodler and Giovanni Segantini. A response to Monet's *Water Lilies* shown at the start of this suite of rooms, they also exemplify some essential Early Modern attempts at a holistic perspective on landscape, nature and art (see pp. 52–53).

The Kunsthaus's holdings of Abstract Expressionism and Cy Twombly have been brought close to the rooms containing the Looser Collection on the first floor, with its major works by artists including Willem de Kooning, producing a cluster that extends almost the entire length of the building and is dominated by the large, mostly abstract American painting of the post-war period. Art of the present day makes its most prominent appearance towards Heimplatz, where everything from works of the 1960s to the very latest installations is on display. On the other side of the building, the Merzbacher Collection, dominated by groups of Expressionist and Fauvist works – now including a version of Pipilotti Rist's *Turicum Pixel Forest* (2021) – makes up a distinctive and interesting exhibition segment that the collector himself initiated. He has spoken of the vitalizing effect that art dominated by colour and light exerts upon him. It has given him his motivation to enjoy life to the full, despite the terrible events that afflicted his family during the Nazi era.

Opposite these thematically rounded sections, other parts of the Chipperfield building are organized on a smaller scale, with contrast being the dominant categorization. An inner sequence of rooms on the first floor, running parallel with the 'American' enfilade, consists of individual, thematically separate spaces. Beneath them are rooms devoted to digital art, Dada and video art respectively, as well as an intervention space that is occupied for the opening by contemporary feminist art (see p. 84).

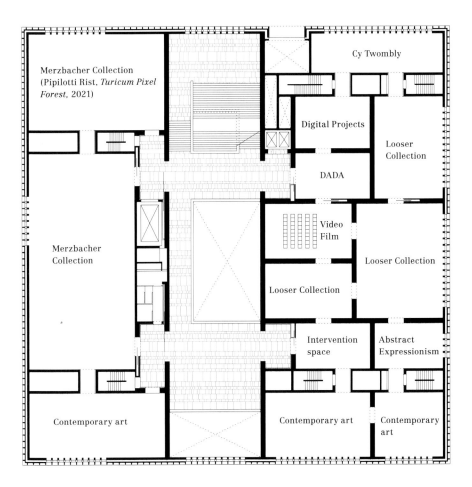

First floor of the Chipperfield building

Second floor of the Chipperfield building

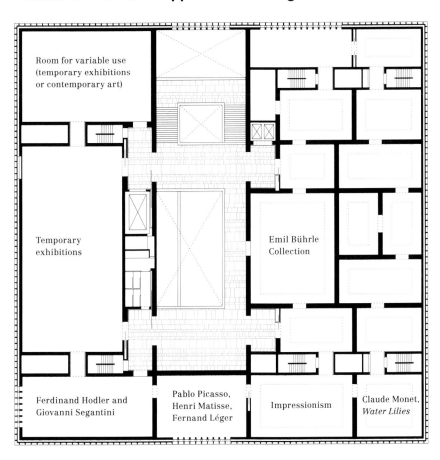

Art of the present day is a central theme overall, with three further rooms devoted to it at the time of opening. One revisits the American topic in a very particular way, with monumental, copper sculptures by the Vietnamese-born Danish artist Danh Võ: fragments of a life-size replica of New York's Statue of Liberty (see pp. 82–83). Other parts of the massive effigy are spread around the world: the artist deliberately plays with the impossibility of reuniting them in a single place and 'reconstructing' the statue. It is a powerful image of the collapse of the once great idea of freedom.

Accompanying it is another room holding cool masterpieces by Andy Warhol and Gerhard Richter from the 1960s, made using the techniques of photography and screen printing. Employing media in a very modern way for their time, they present a different America: darker than we find in the large paintings by Mark Rothko, Barnett Newman and Willem de Kooning in the rooms on the other side, where concentrated perception is central to the experience.

On the second floor, towards the garden, art of the late 19th and early 20th centuries comes up against unflinching, contemporary content. An installation by the South African artist Lungiswa Gqunta is a striking portrayal of marginalization and social injustice – themes that, as Mirjam Varadinis points out in her article, are not confined to her homeland (see p. 88). Next to it, a work by the Mexican artist Teresa Margolles tackles present-day violence against women in the Mexican border town of Ciudad Juárez. These works show how the Kunsthaus has focused its collection activities more strongly on non-European art over recent years, and begun to address issues such as colonialism and gender. Temporary presentations of contemporary art will continue this trend.

In summary, then, the extended Kunsthaus will cover a vast spectrum, with art from the Middle Ages to the present day, works both canonical and non-canonical, numerous exhibits by male artists and – at last – many more by female artists. With its holdings grouped into clusters, the new setting will form a living matrix of contrasts and paint a multilayered picture of the capabilities of art. Highlighting the contrasts between the activities of museums and the passion of private collectors, it also explicitly tackles the topic of art collecting in general, and the background to it. As the story of the Emil Bührle Collection – assembled in Zurich by a collector with close ties to the Kunsthaus – reminds us, our institution is linked to historical processes and constellations that call for in-depth engagement, in the best sense of the term. The enlarged Kunsthaus offers time and space for that, too.

In the months following the opening, many of the works from the collection will also be on display in the special exhibition *Earth Beats*. It is described as 'an artists' plea to preserve the Earth and its natural resources for future generations, born out of the urgency of the present situation.'

Philippe Büttner

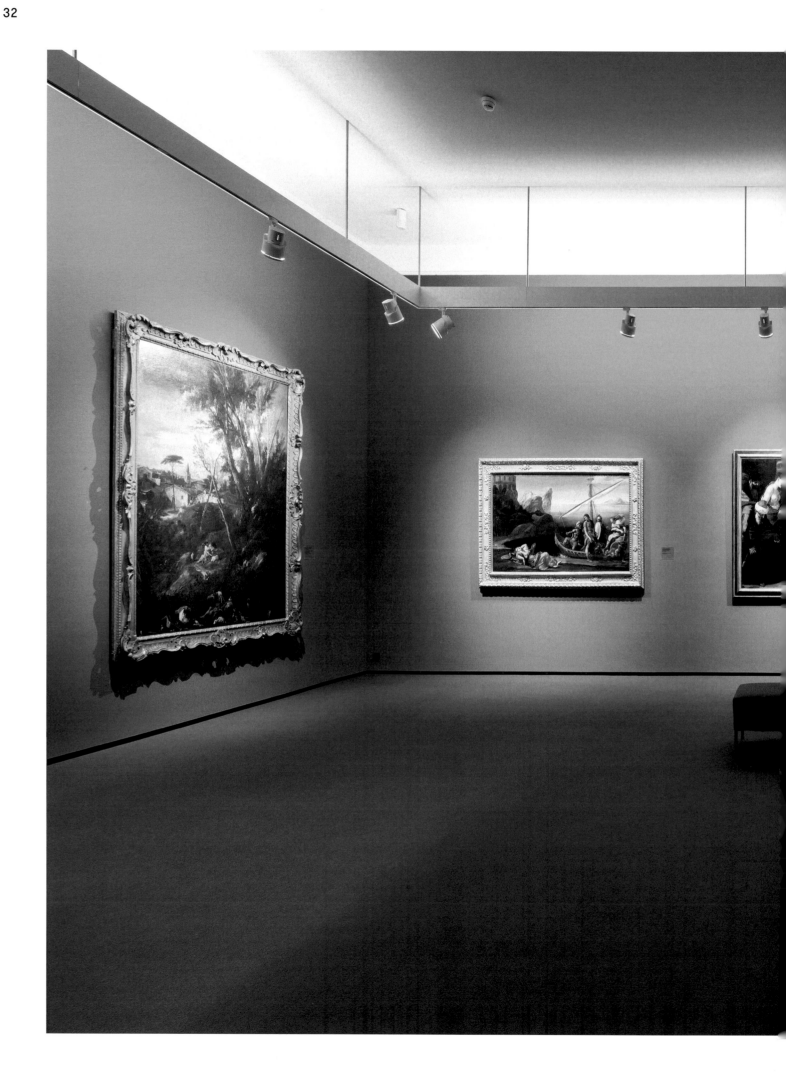

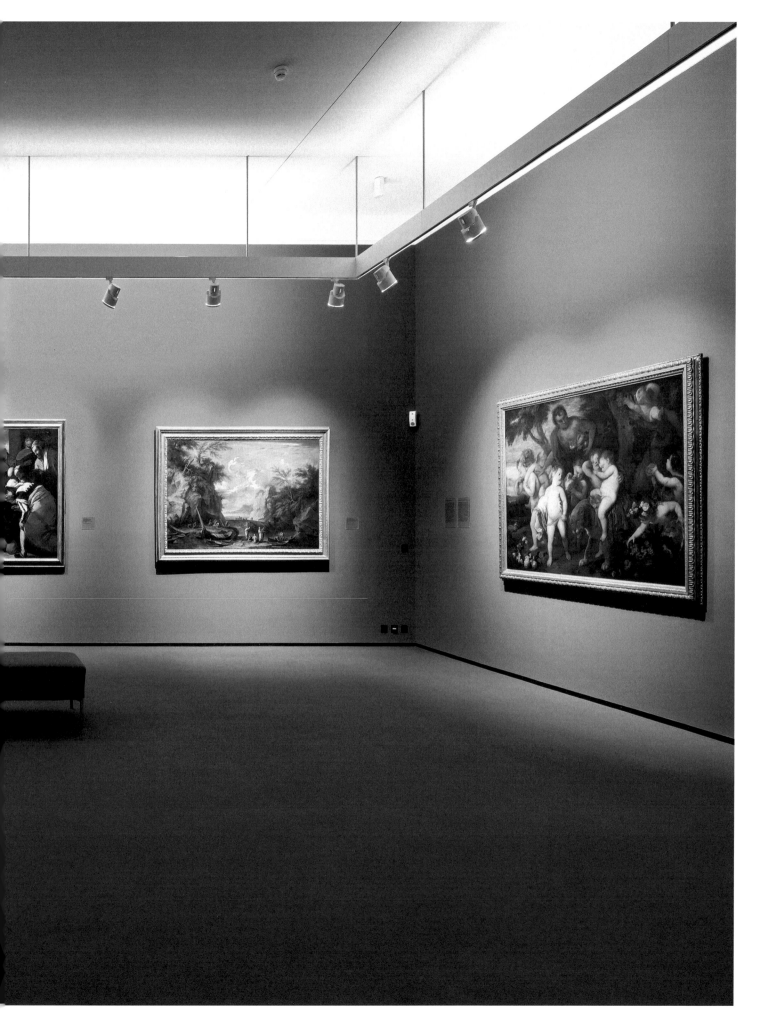

Moser building, Italian and
Flemish paintings from
the 17th and 18th centuries

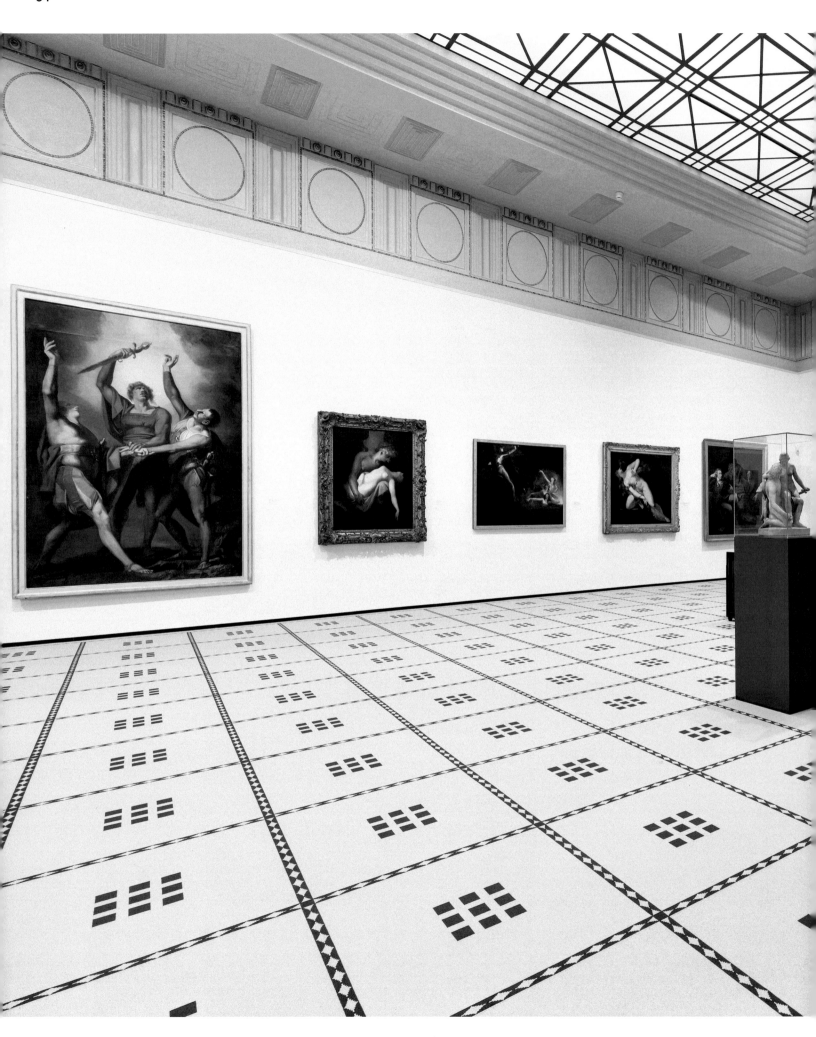

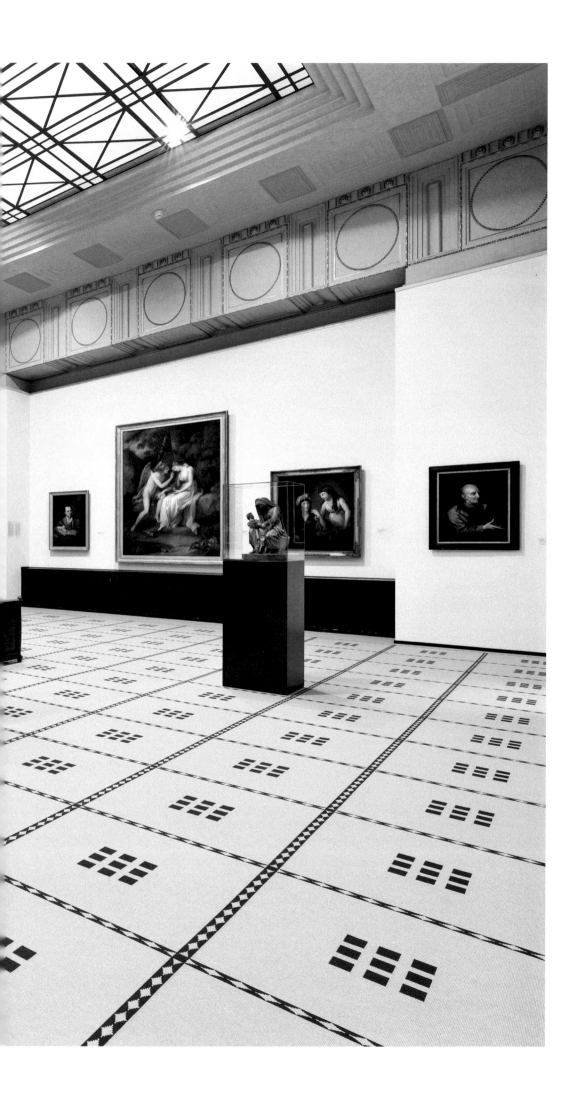

Moser building with,
among others,
works by Henry Fuseli,
Angelica Kauffmann
and Alexander Trippel

Following spread
Moser building,
paintings by
Karl Stauffer-Bern
and Rudolf Koller

COLONIAL ISSUES IN HISTORICAL AND CONTEMPORARY ART

For many years, the central domed room of the 1910 Moser building was used to display works by Arnold Böcklin (1827–1901). With the reorganization of the collection, this area now has a new function: as one of a number of 'intervention spaces' spread around various parts of the buildings, it places the surrounding collection holdings in a new context.

The works of Anna Boghiguian (b.1946) and Kader Attia (b.1970) reflect on the history of colonialism and its legacy in today's society. The two pieces on display here, directly adjacent to the 17th-century Dutch paintings, invite viewers to reflect on the complex story of exploitation and slavery that had its roots in Europe, and in which Switzerland too was involved in many ways.

Images of slaves

The postcolonial discourse is one of the most prominent issues of our time. Scrutiny of the colonial past has been particularly intense in the Netherlands, with museum exhibitions also playing their part. Given that the the nation (which here can serve as an example for many countries and societies in Europe) was a great trading power heavily involved in the international slave trade, was the 17th-century Dutch 'Golden Age' really so 'golden'?

The works of the Old Dutch Masters unquestionably were. Yet on closer inspection, even they contain hints of the darker side to that great century of painting: treasures from exotic lands, or the magnificent sailing ships without which the burgeoning global trade would have been inconceivable. Some are even more specific, as in the fine *Harbour Scene with Galley Slaves* (c.1652) by Jan Asselijn (1610–1652), a Dutch painter of French descent. He was one of the 'Italianate' artists whose works typically evoked the scenery of southern Europe, and especially Italy. Such views were popular in Holland and they sold well.

At first sight, the painting depicts nothing more than a light, atmospheric harbour scene. A couple of figures are sitting by an old, round construction on the shore; a ship and a fountain can also be seen. Look closer, however, and the picture changes: we see that the seated man in the yellow coat and his companion drinking from the fountain are both chained at the ankles: as Jean Michel Massing has pointed out, the two are galley slaves. The man with a sword on the left is probably an overseer; the man standing in front of him and pointing to the sea may be a ship owner. The intent of these details is not immediately obvious. Was the artist subliminally addressing the issue of slavery? Or was he simply interested in exotic motifs? Current debates and the revisiting of colonial history encourage us to read such works in a new way. Artists of the present day are also playing their part in this process.

Jan Asselijn, *Harbour
Scene with Galley Slaves,*
c. 1652 (detail)

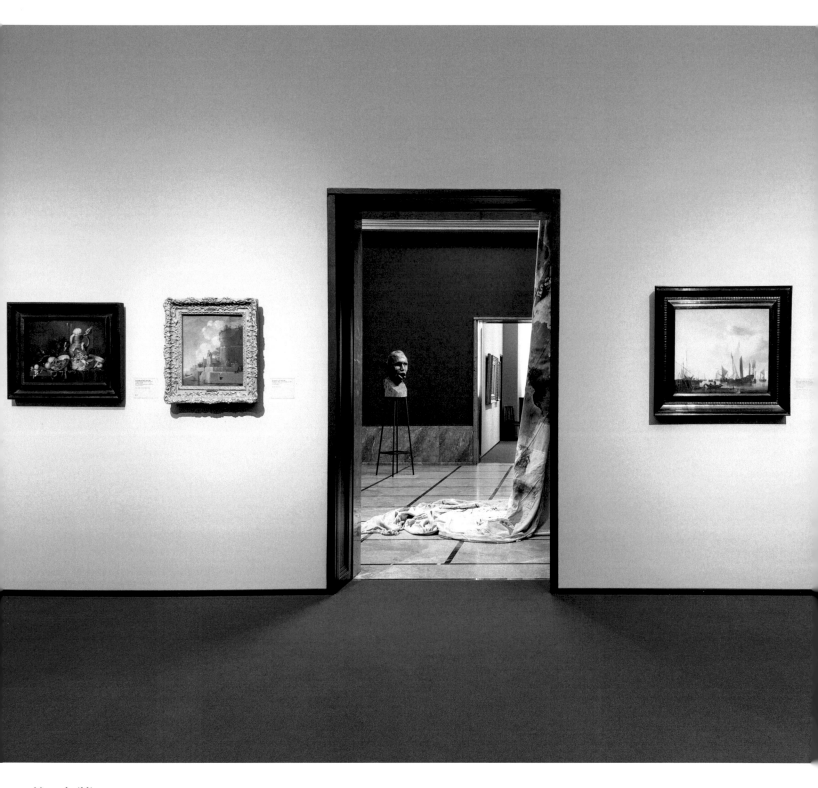

Moser building,
Netherlandish paintings
from the 17th century
and contemporary works
by Anna Boghiguian
and Kader Attia

Setting sail

Egyptian-Canadian artist Anna Boghiguian is of Armenian origin, and creates artist's books, drawings, collages and striking installations on her travels through various continents. For her the sail – a frequent motif in her work – is the expression of the nomadic life that she leads on account of both her Armenian roots and her existence as an artist.

Untitled (2018), the work on display here, deals with three great revolutions of human history: the Industrial Revolution, directly linked to the history of slavery by the vast demand for cotton at the time; the Spice War between the colonial powers and the concomitant rise of nationalistic sentiments; and the Digital Revolution, with the hegemony of the US and its companies such as Facebook and Google.

The wounds of history

Kader Attia was born to Algerian parents in a suburb north of Paris. Now working in Berlin and Paris, he draws on the experience of living between two cultures as the basis for his visual practice. The themes of injury and repair play a central role in Attia's work, in which he investigates the various concepts that lie behind those terms in both the Western and the non-Western world.

Culture, Another Nature Repaired (2014) depicts the disfigured face of a soldier who survived the First World War. Known in French as 'gueules cassées', these wounded combatants were scarred for life by the terrible injuries they had suffered. Kader Attia travelled to Senegal with photos of such men that he had found in German and French historical archives and, working with traditional craftspeople, sculpted busts from the photos. The work deals with the horrors of war but also references the relationship between Western modernity and Africa – and turns history around.

Mirjam Varadinis and Philippe Büttner

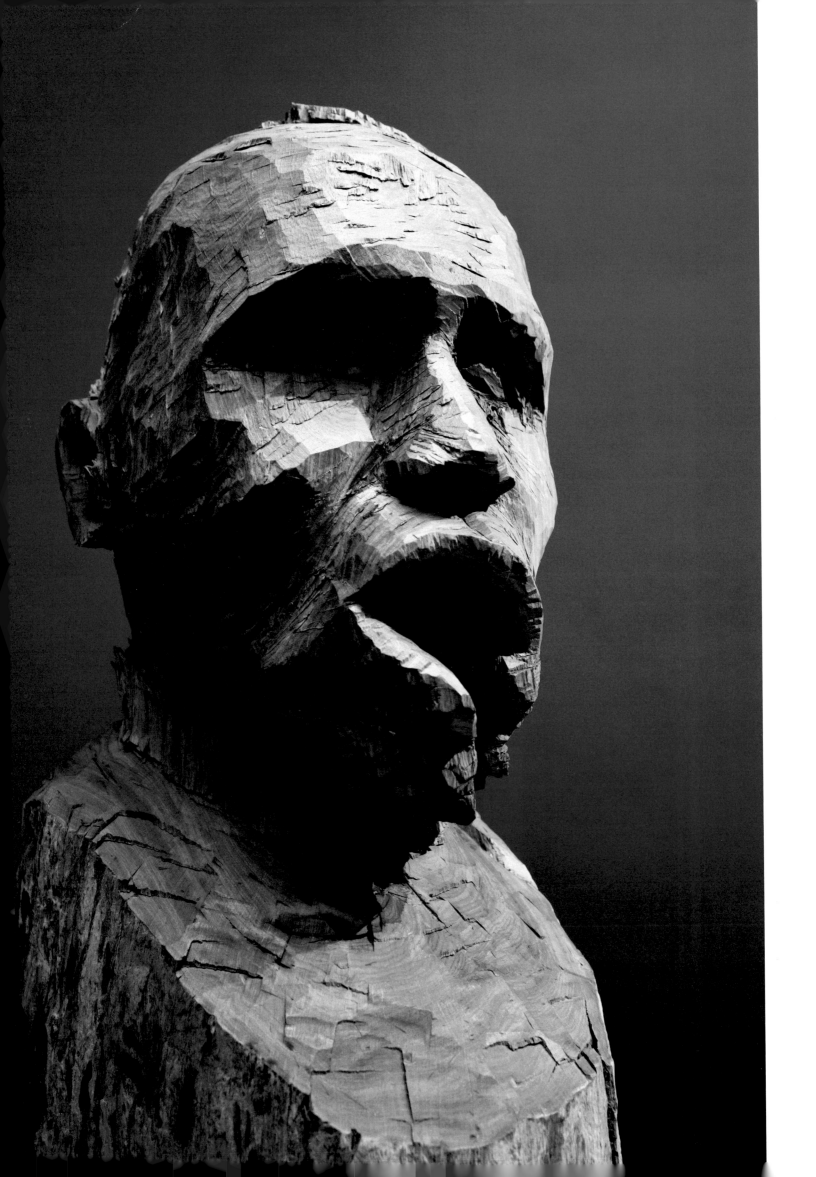

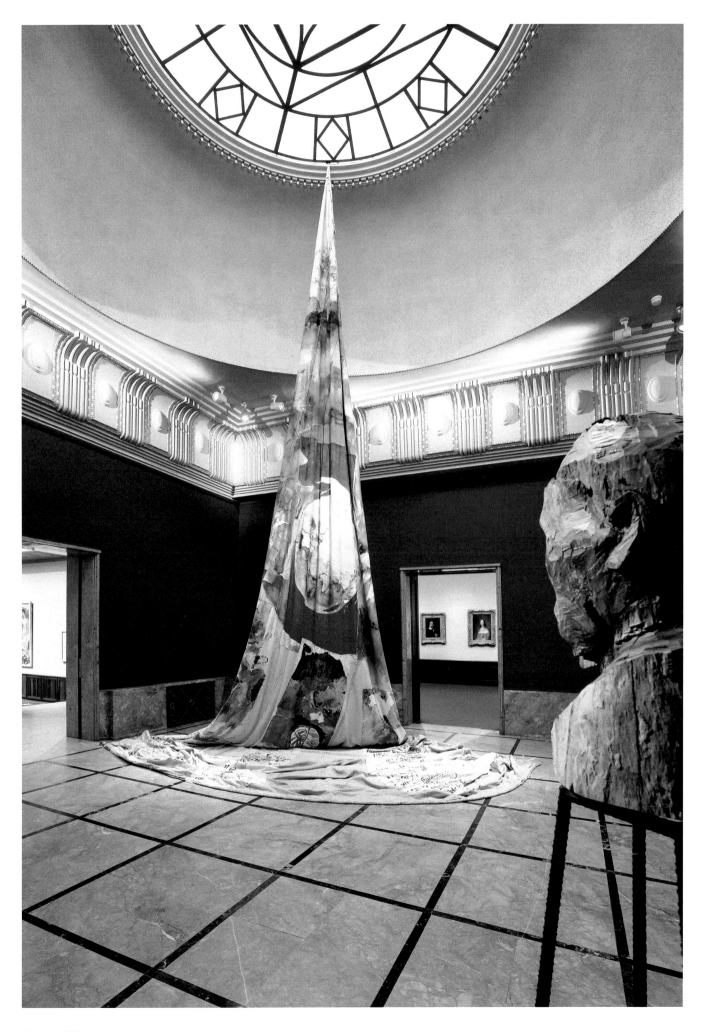

Moser building,
contemporary works
by Anna Boghiguian
and Kader Attia

FROM CLAUDE MONET TO FERDINAND HODLER: NEW PERSPECTIVES ON THE VISIBLE

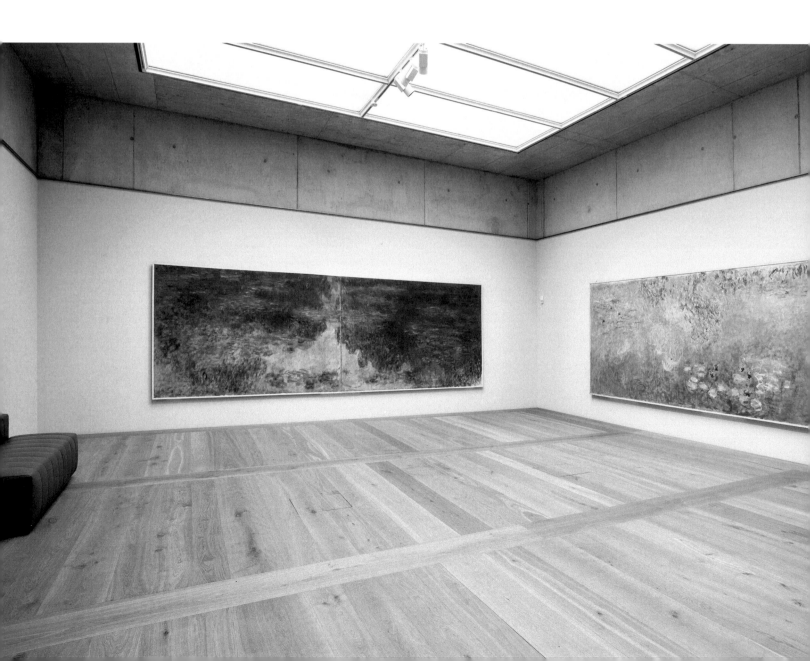

On the second floor of the extension are four magnificent rooms devoted to Impressionist painting, Classical Modernism in Paris, and the landscapes of Ferdinand Hodler and Giovanni Segantini.

Claude Monet's *Water Lilies*

Emil Bührle donated two water-lily paintings by Claude Monet (1840–1926) to the Kunsthaus Zürich in 1952; these are now enduringly reunited in the Kunsthaus with a third drawn from the Emil Bührle Collection. The *Water Lilies* thus tie the two collections together.

Monet's late water-lily pictures are his final contribution to modern art and an entirely novel departure: when painting them, the artist lowered his gaze for the first time beneath the horizon that had defined previous centuries of landscape images, and focused solely on the surface of the water, which thus becomes the twin of the canvas on which it is reproduced. Consequently, for the first time, the painting was transformed into a membrane for a large, flowing whole – an 'all-over' work of art, as the Americans later dubbed this form of borderless painting.

Monet's huge *Water Lilies* were painted in a time of war, and perhaps in response to it. More than once, the front line advanced to within fifty kilometres of Giverny, where he lived and where sometimes, it is said, the sound of battle could be heard. The tranquil flowering plants thus offered a vision to counter the catastrophic and devastating conflict.

Impressionism and Post-Impressionism

Within sight of the corresponding masterpieces from the Emil Bührle Collection, a second room brings together the main Impressionist and Post-Impressionist works from the Kunsthaus Collection, along with important long-term loans from private collectors. A particular tone is set by works from the period after 1888, including three by Claude Monet and the Post-Impressionist paintings of Paul Cézanne, Vincent van Gogh and Paul Gauguin.

The characteristic feature of Impressionism is the technique of painting in dabs of pure colour, which blend together not on the artist's palette but in the eye of the beholder, thus expressing the momentary nature of perception. Post-Impressionist painting goes a step further. In Cézanne's (1839–1906) rhythmic flecks of colour, the paint is accorded a status equal to the visible world which it depicts. Van Gogh (1853–1890), meanwhile, transformed the Impressionists' flocculent brushwork into dynamic strokes pulsating with emotion. Gauguin (1848–1903), on the other hand, enlivened his pictures with arabesques often made up of figures, and so completely restructured the areas of colour.

Also represented in this room are the Neo-Impressionism or Pointillism of Georges Seurat (1859–1891) and Paul Signac (1863–1935), ushering in a systematic approach to perception and the application of colour that for a time also influenced Henri Matisse.

Chipperfield building,
paintings by Claude Monet

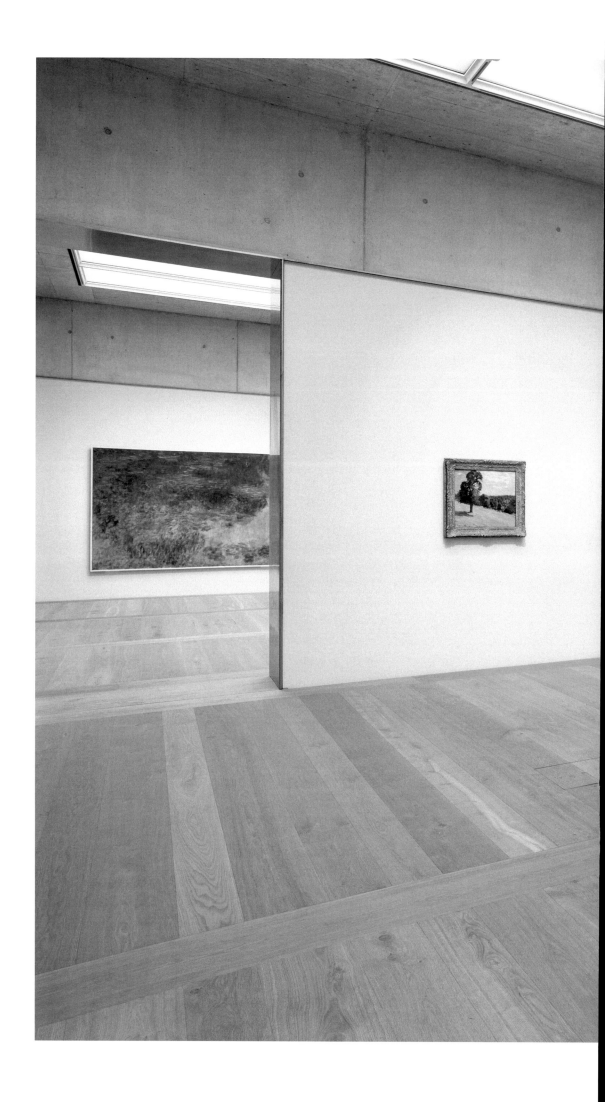

Chipperfield building,
works by Claude Monet,
Camille Pissarro,
Alfred Sisley
and Auguste Rodin

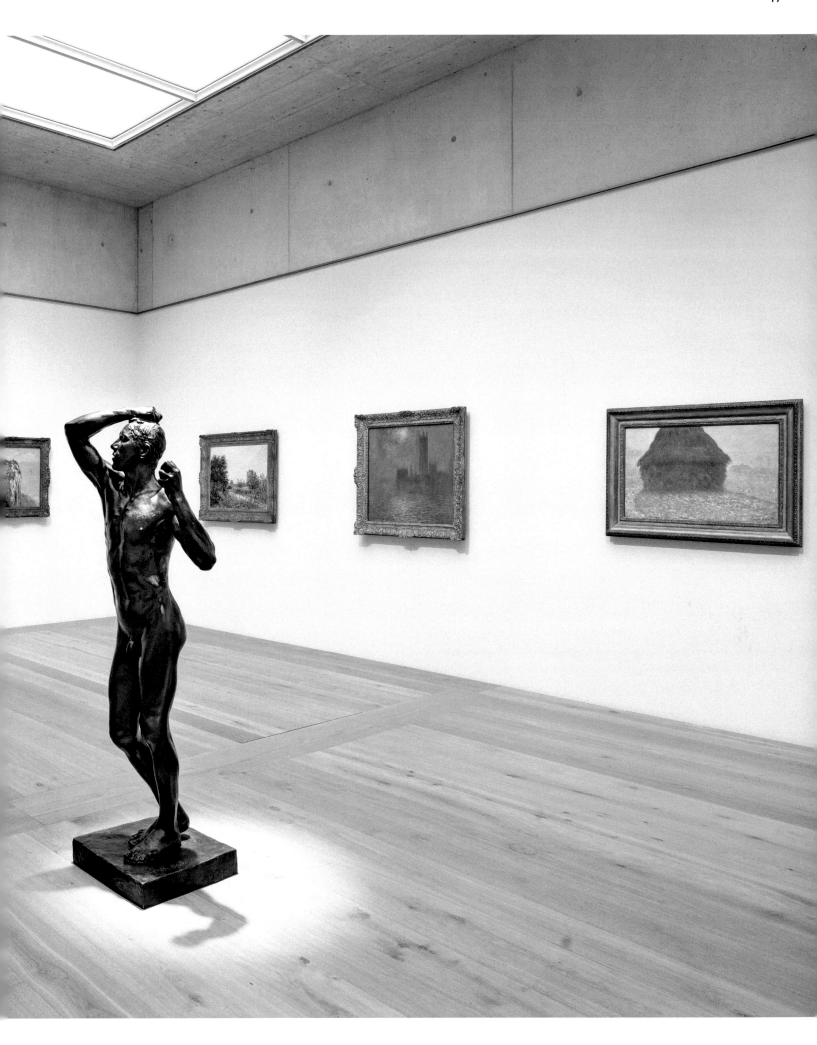

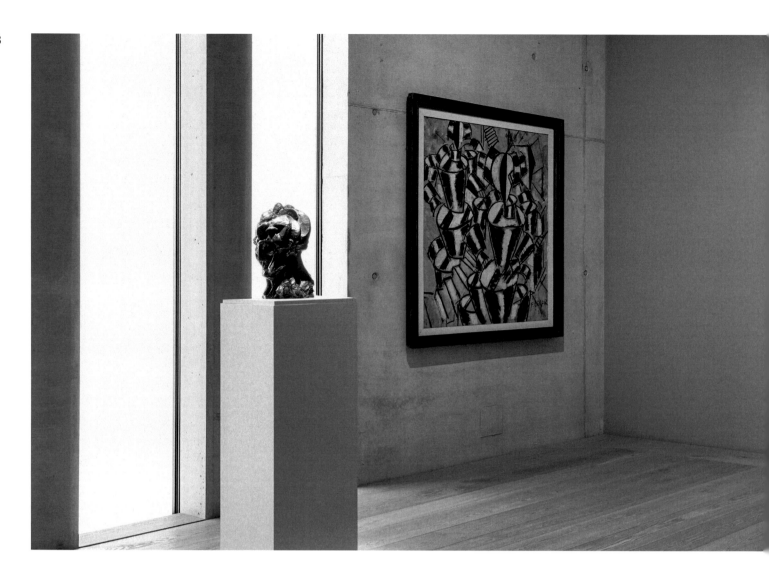

Classical Modernism in France

The room devoted to Classical Modernism brings together artists who spent key phases of their artistic careers in Paris. Pablo Picasso travelled to the French capital for the first time in 1901. That year he produced his brilliant early self-portrait *I Picasso* – on loan here from a private collection – which betrays the influence of Henri de Toulouse-Lautrec. The Cubist painting *Guitar on a Pedestal Table* (1915) was acquired by the Kunsthaus direct from the artist in 1932 when his first major museum exhibition was staged here.

Beginning in 1909, the Cubism of Picasso and Georges Braque picked up where Cézanne had left off, transforming painting into a laboratory for modern artists' conceptions of the world. The resources of painting were radically mobilized for their own sake: lines, shades of colour, formal rhythms and areas of layering that create the illusion of space. Far from being simply depicted, the visible world was now reconstructed in controlled fashion through the image, on the strength of its own reality.

Picasso's *Big Nude* (1964) blends the personal with the mythical: the subject, the artist's second and last wife Jacqueline, is depicted in a posture that echoes the archetypal recumbent Venus familiar from the works of Giorgione and Titian.

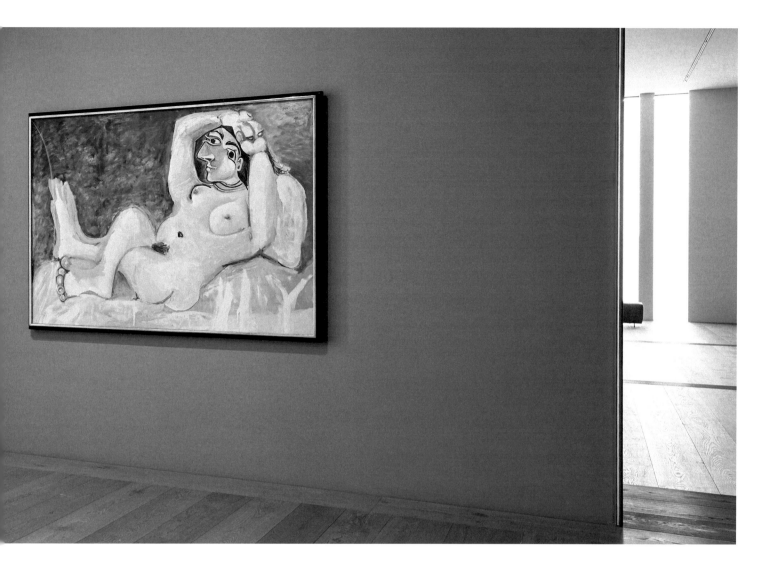

Chipperfield building,
works by Pablo Picasso
and Fernand Léger

Finally, Henri Matisse (1869–1954), the great colourist of modern-
ism, is represented by a number of works, including two fine early
paintings: *Barbizon* (1908) is a homage to the Barbizon School, a
group of artists who dedicated themselves to painting outdoors, 'en
plein air'; *Margot* (1906) is a striking Fauvist portrait of his daughter,
whose name was actually Marguerite. In 1960, the Kunsthaus acquired
four monumental nudes known as the *Backs* created by her father, which
are now on display in the Moser building.

A refined image by Alice Bailly (1872–1938), a painter originally from the
Swiss canton of Vaud who mainly worked in Paris prior to the First World
War, complements the Matisses. The dynamically colourful pre-war Cub-
ism of Fernand Léger's *The Stairway* (1913), on the other hand, is a sculp-
ture-like structure of integrated forms that are themselves assembled
from individual forms. Enlisted as a soldier in the First World War, Léger
employed Cubist techniques in drawings to express the fragmentation and
dismemberment of human bodies in war. This treatment of the conflict is
diametrically opposed to that of the late Monet in his holistic, large *Water
Lilies*. As *The Stairway* makes clear, aside from this trauma Léger was posi-
tively disposed to the incipient age of technology, as was Robert Delaunay,
whose large *Circular Forms* (1930) in the foyer celebrates the orphic potential
of a modernity experienced as exhilarating.

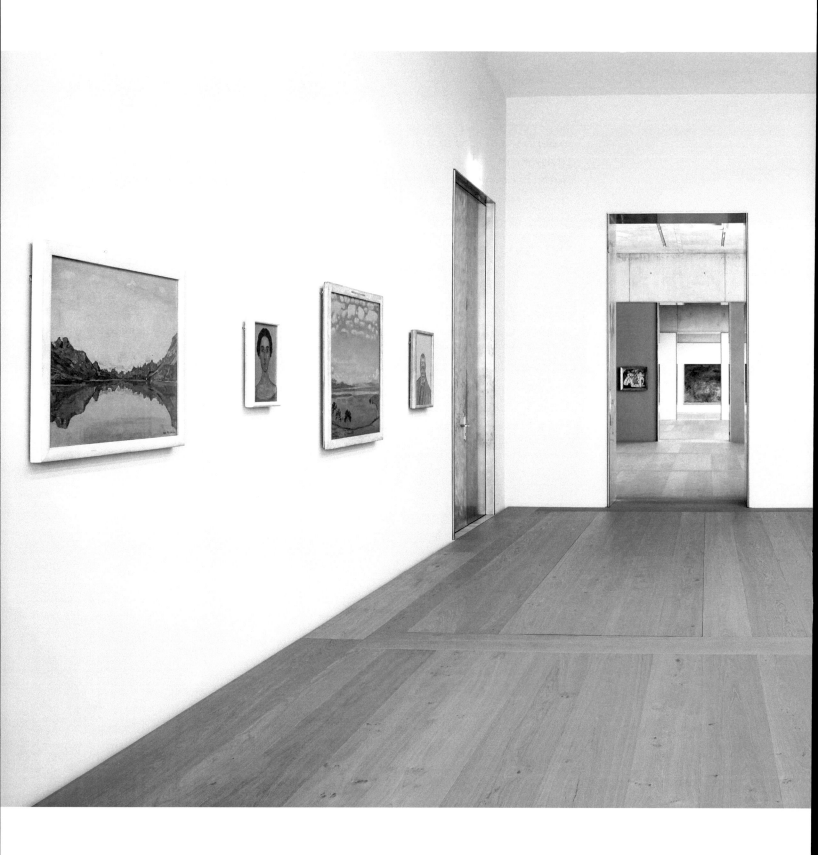

Ferdinand Hodler and Giovanni Segantini

Ferdinand Hodler (1853–1918) and Giovanni Segantini (1858–1899), two key exponents of Early Modern painting in Switzerland, are represented here primarily by their landscapes, in which an allegorical Symbolism helped them along the way to fundamentally new formulations of painting.

Hodler's landscapes are quite unlike the momentary sensations captured by Impressionism: instead, they are spaces exposed to eternity. For Hodler, human beings were transient, at first standing upright before being forced into the horizontality of death; but so were the high mountains, gradually crumbling down the ages and ultimately themselves becoming horizontal in the depths of time. Segantini, like Hodler, moves between Symbolist vision and modern experience of landscape. Yet a colour technique influenced by Italian Divisionism – a variant of Pointillism – takes him down a different path: Segantini constructed his overall view of the world in almost abstract fashion, from dense, luminous lineaments of paint.

These two key figures bring us back to Monet, because their landscapes – like his *Water Lilies* – exemplify the Early Modern concept of a totality that is no longer simply depicted by the painting, but is actively generated by it.

Philippe Büttner

Chipperfield building,
series of rooms
with works by Ferdinand
Hodler, Alice Bailly
and Claude Monet

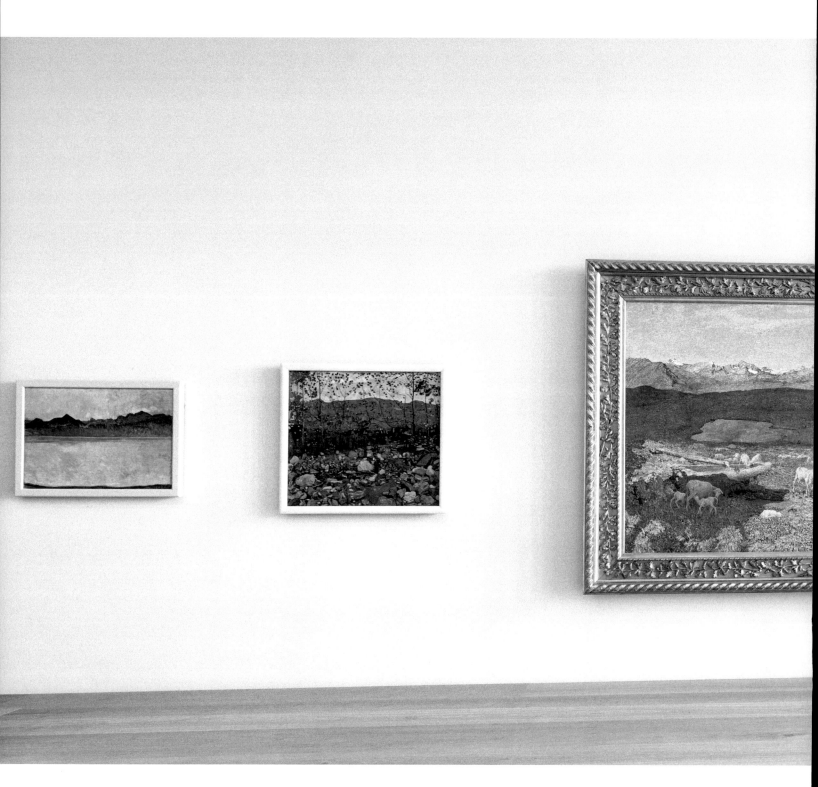

Chipperfield building,
works by Ferdinand
Hodler, Giovanni Segantini
and Auguste Rodin

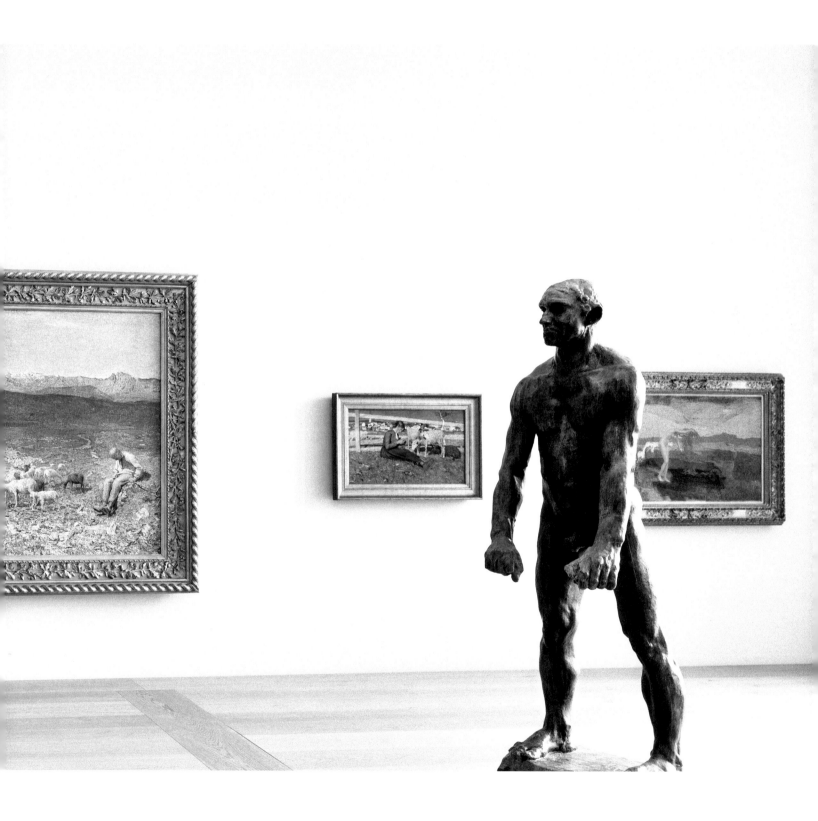

FROM ALBERTO GIACOMETTI TO CY TWOMBLY

The Müller building contains an extensive display of the works of Alberto Giacometti (1901–1966), with selected pieces by other artists adding further context. Today, Giacometti is still best known for his body of Surrealist work and, above all, his iconic, figural oeuvre from the post-war period: he was one of a group of well-known artists – including Pablo Picasso, Francis Bacon and Germaine Richier – who defied the dominance of abstraction after the Second World War by maintaining the presence of the human image in art.

Giacometti had a specific objective in mind that emerges with particular clarity in his sculptures, which were first modelled in clay: for him, what mattered was not to reproduce the physical features of a model, but rather to convey his own perception of the person in front of him. As he worked, his hands were thus guided by the inner vision of what he saw, as he sought to express the intangible manifestation of a figure.

It is therefore somewhat ironic that André Breton, leader of the Surrealists, expelled Giacometti from the group in 1935 precisely because he had started working from models again. 'Everyone knows what a head looks like,' growled the austere high priest of Surrealism, who believed that art must draw its content from the realm of the unconscious.

Following the outbreak of war, most of the Surrealists – including André Breton – fled to New York to escape from fascism. There, the ideas shaped by Breton soon fed through into the American art scene, not least the youthful artists who would later give birth to Abstract Expressionism. The latter absorbed the lessons of Surrealism but moved beyond them to develop an entirely new art in which paint alone, worked into pictures of ever larger format, became the medium for the artistic narrative. The focus now shifted to the shamanic liberation of energy-laden paint drips by the likes of Jackson Pollock (1912–1956), or what Mark Rothko (1903–1970) called the 'consummated experience between picture and onlooker'. Barnett Newman (1905–1970), in his statement 'The Sublime is Now', postulated the presence of something nameless and ineffable in the actuality of the image. The new American art thus again distanced itself from the Surrealism of the Old World and its verbal structuring informed by André Breton's cool encyclicals on the dark side of humanity and the non-causal leaps of associative writing and speech. Abstract Expressionism, by contrast, was an art beyond words.

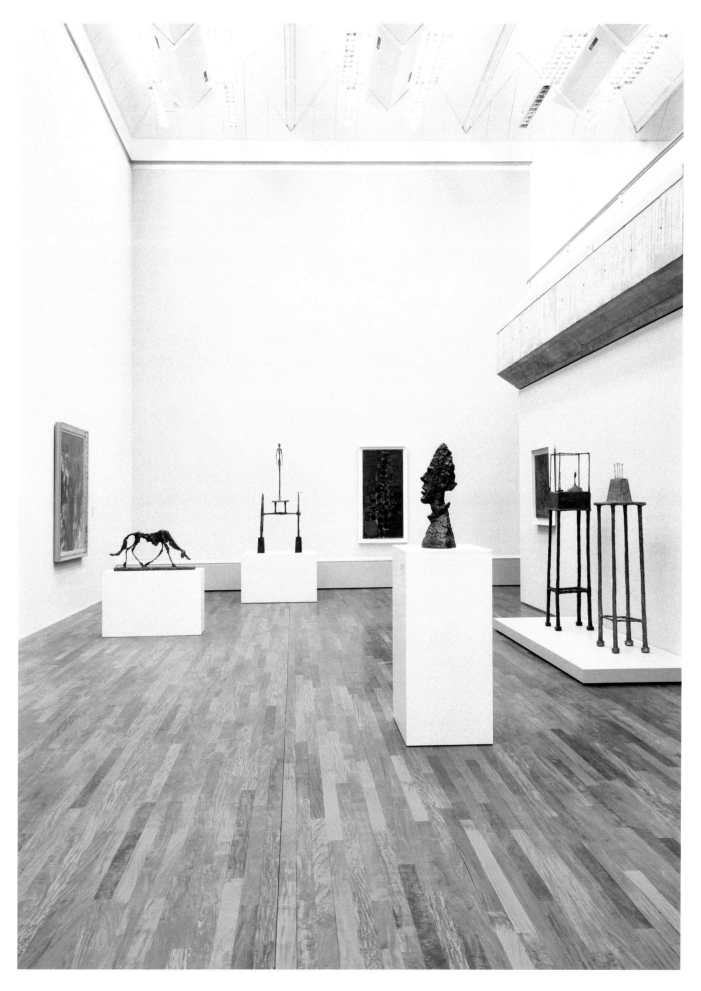

Müller building, works
by Alberto Giacometti,
Francis Bacon
and Nicolas de Staël

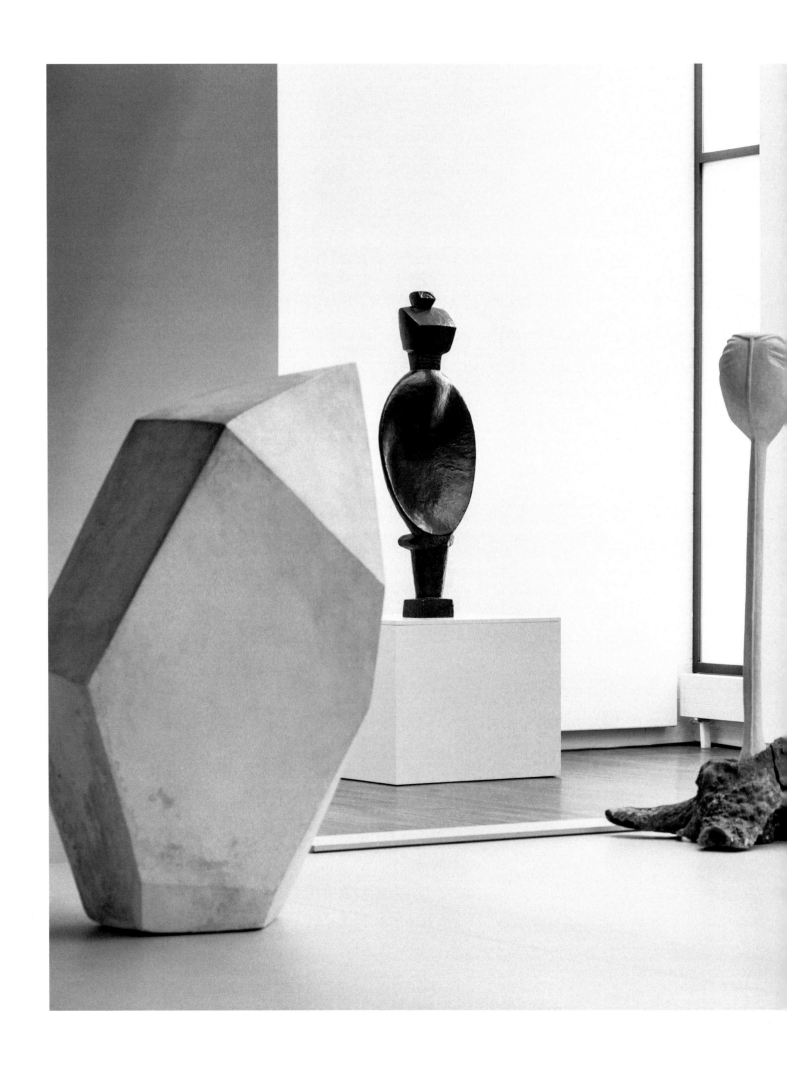

Müller building,
works by Alberto
Giacometti, Meret
Oppenheim and
Constantin Brancusi

Chipperfield building,
works by Jackson
Pollock, Sonja Sekula
and Mark Rothko

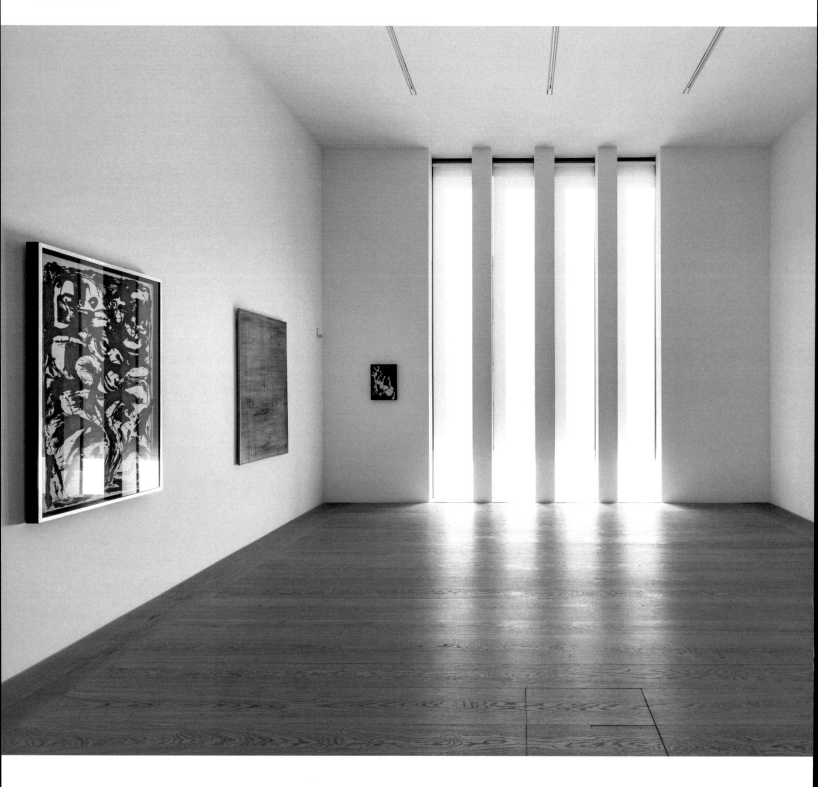

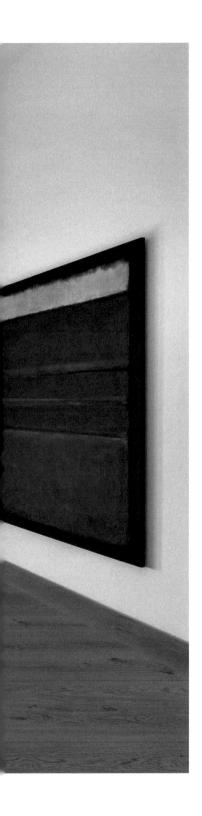

The Kunsthaus extension displays some key works by Mark Rothko, Barnett Newman and Jackson Pollock personifying the first generation of this important movement. Those 'angry young men' are joined here by the Swiss Sonja Sekula (1918–1963), who lived in New York from 1936 to 1955 and came within the ambit of the émigré Surrealists and the Abstract Expressionists.

Within the Looser Collection, David Smith (1906–1965) and, especially, Willem de Kooning (1904–1997) represent additional facets and developments of Abstract Expressionism.

Another artist whose formative years were directly influenced by the rise of Abstract Expressionism was the American painter, sculptor, draughtsman and photographer Cy Twombly (1928–2011). Although versed in the formal 'flow' of this new art, the young Twombly nevertheless sought new inspiration as he travelled extensively to North Africa and Egypt, Italy and Greece. In his adopted Italian home, he opened up to the brightly shimmering world of the Mediterranean and its dark myths, as well as to classical mythology, and began to blend the Abstract Expressionists' wordless 'all-over' with a new kind of language. Texts and contexts flooded his images; Twombly scribbled mythical names and actions onto his canvases and used them to create a stammering anti-speech close to the oracle of Antiquity. The written elements of his works are often at the limit of legibility, and sometimes tip over into the purely symbolic or abstract. These letters are precarious; yet precisely for that reason, the myth can be reignited in the moment of their decoding. For Twombly, things that are located at the threshold of perception seem especially fundamental. Moving from one building to another, we thus come full circle back to Alberto Giacometti.

The Kunsthaus displays an important group of paintings and sculptures by Twombly on the first floor of the extension. The sculptures – nine in total – were donated by the artist in 1994. They are complemented by Twomblys from the Looser Collection in the adjoining rooms.

Philippe Büttner

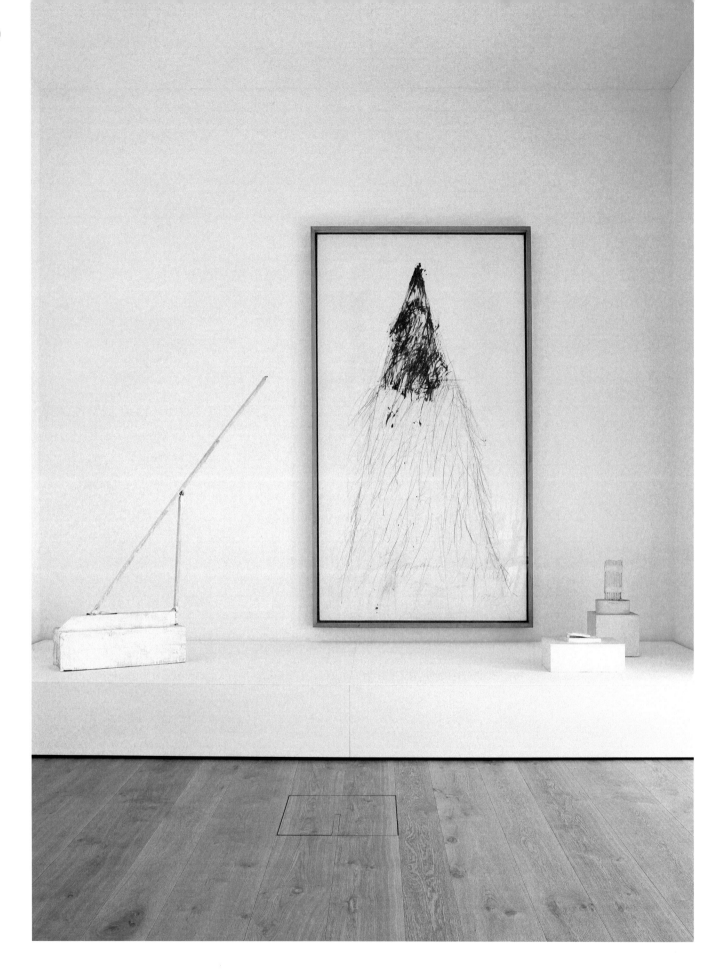

Chipperfield building,
works by Cy Twombly

FROM POP ART TO MINIMAL

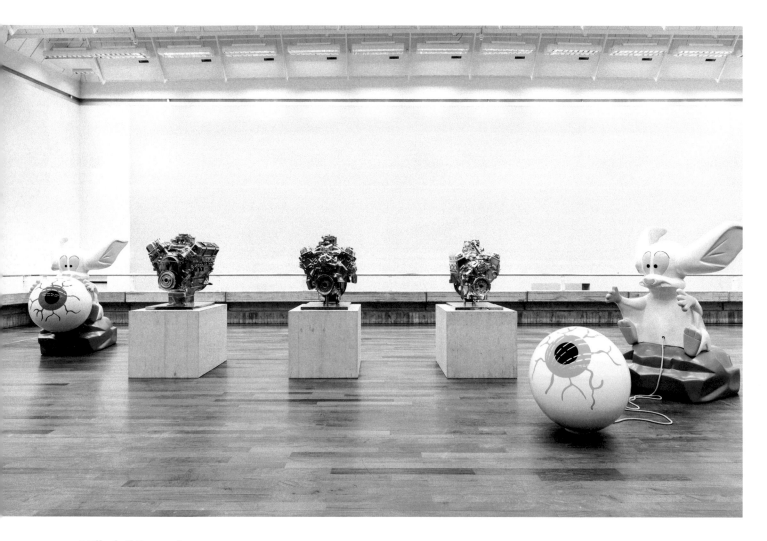

Müller building, works
by Sylvie Fleury

The Kunsthaus Zürich holds a number of important works of Pop Art.
They include *Interior I* (1964) by Richard Hamilton, *Yellow Brushstroke*
(1965) by Roy Lichtenstein and *Big Torn Campbell's Soup Can (Vegetable
Beef)* (1962) by Andy Warhol. Another is Robert Rauschenberg's large-
format *Overdraw (untitled)* (1963), which can be seen on the mezzanine
floor of the Müller building. Here, American and British Pop Art hang side
by side, setting up a dialogue between Rauschenberg and Hamilton. The
Kunsthaus does not hold any works by female artists from this period, and
it therefore invited the Swiss artist Sylvie Fleury (b.1961) to respond to the
works of her male counterparts from the 1960s with a large installation of
her own. Like them, she makes the world of commodities and consumerism a
key theme of her work – but hers is always a distinctly female perspective.
She takes motifs and products from the fashion and cosmetics industries and
transforms them into works of art that attest to a fascination with the world of

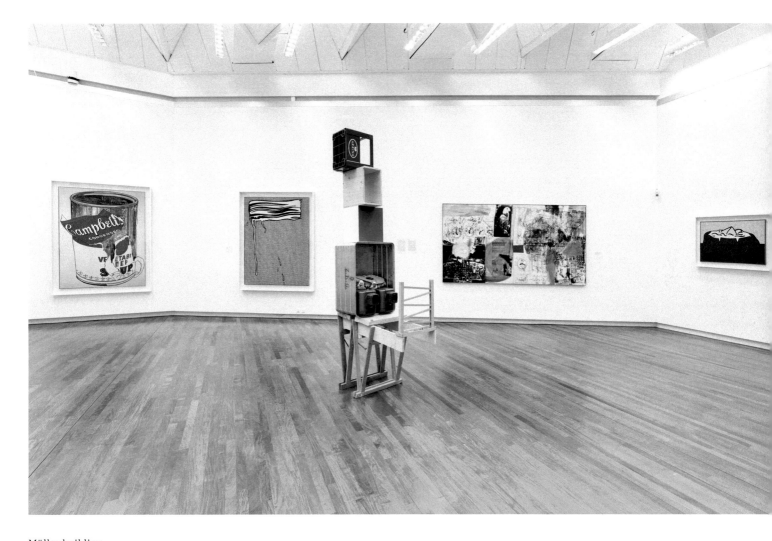

Müller building,
American Pop Art
by Andy Warhol,
Roy Lichtenstein, Robert
Rauschenberg and
a work by Abraham
Cruzvillegas

luxury but invariably interrogate it, tongue firmly in cheek and with surprising levity.

Sylvie Fleury's subjects are not drawn exclusively from the world of fashion: cars and engines have always played an important role in her output. In 1998 she set up the She-Devils on Wheels automobile club, named after a 1960s film in which an all-female motorcycle gang exacts merciless revenge on the male world. Here we see Fleury's underlying feminism at work: for her, it is impossible to be an artist in today's world without also being a feminist.

The three sculptures on show here are bronze casts of powerful engines from customized American cars. The gleaming, silvery sculptures reach across to the machines of Jean Tinguely (1925–1991) that can be seen directly adjacent to them. The *Cycloengraver* (1960) is typical of Tinguely's absurd machine sculptures. Originally, visitors were permitted to sit on the bicycle welded

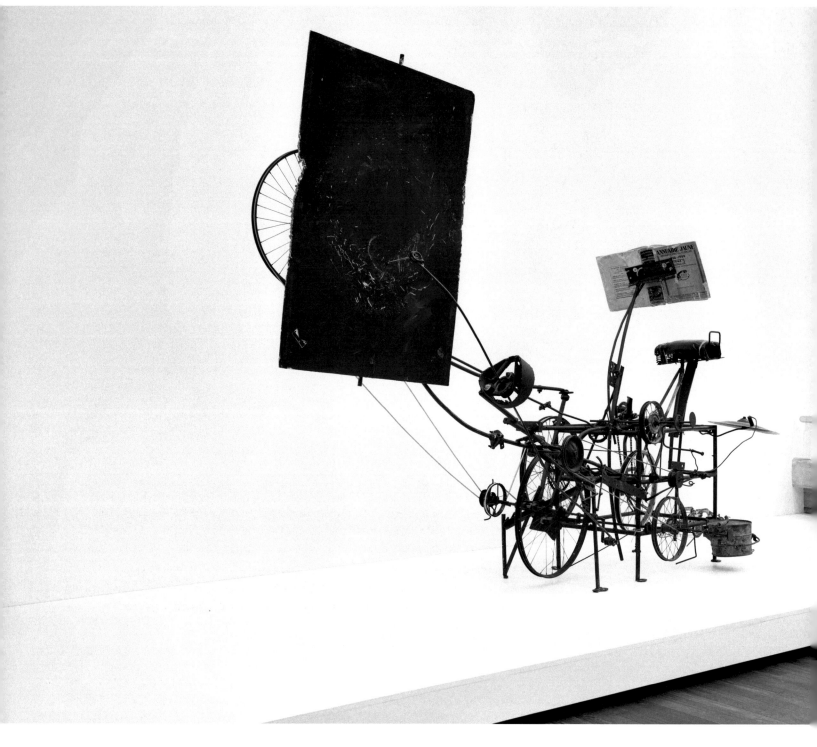

A work by Jean Tinguely
in the Müller building

together from recycled metal, moving the stylus attached to the front by turning the pedals, and so tracing out an abstract work of art. The *Meta-Mechanical Sound Relief I* (1955) shown next to it is also actually a kinetic artwork. Here, for the first time, Tinguely used everyday objects such as cans, funnels, glasses and bottles to create sounds in a surprising, unpredictable sequence. The viewer's eye invariably lagged behind the acoustic event, upending the traditional hierarchy of eye and ear. Unfortunately, for conservation reasons, it is no longer possible to set Tinguely's works in motion.

Another artist who adopts a playful approach to found objects is the Mexican Abraham Cruzvillegas (b. 1968), who lives in Paris and counts Tinguely among his important sources of inspiration. The sculpture presented here, *Autokonßtrukschön #1*, was created for Cruzvillegas's solo exhibition at the Kunsthaus Zürich in 2018, and is a continuation of his multi-year project *Autoconstrucción*. This has its roots in the improvised building processes and techniques of his native Mexico City. The artist saw how, in the wake of rural exodus, precarious self-built housing was constructed from the most rudimentary materials found locally, and then adapted to meet changing needs. For Cruzvillegas, the sculptural form is thus always a process of transformation. In *Autokonßtrukschön #1*, he used objects from the Kunsthaus that were earmarked for disposal and items from second-hand shops in the city of Zurich. They include a marble run, which in turn links the work to Sylvie Fleury's oversized toy figures as well as Sigmar Polke's *Shadow Cabinet* (2005), with its silhouettes of animals from a toy circus.

The second floor houses major works of Minimal Art. Following the rehanging of the collection, the architecture here was rearranged to create space for *Model for Tunnel. Square to Triangle* by Bruce Nauman (b. 1941). The work was made in 1981 and consists of a ring-shaped tunnel with a diameter of 6.65 metres. The circle of plaster rests on low, evenly distributed wooden elements and thus floats slightly above the ground. Its solidity makes it impossible to overlook, yet its material gives it a certain lightness. In his model-like arrangements, Nauman links the physical apprehension of space with a psychological experience: the idea of walking through a tunnel with a cross-section that transitions from square to triangle.

Also on display in this room is a video by Anna Winteler (b. 1954), which likewise explores the relationship between body and space and the theme of the serial. Winteler was a leading young Swiss artist of the 1980s and worked extensively in performance but also in sculpture. Today, she has withdrawn from the art world. Still active, however, is the American Jenny Holzer (b. 1950), whose one-line *Truisms* have been making double-edged statements at public locations since 1977.

Mirjam Varadinis

A work by Jenny Holzer
in the Müller building

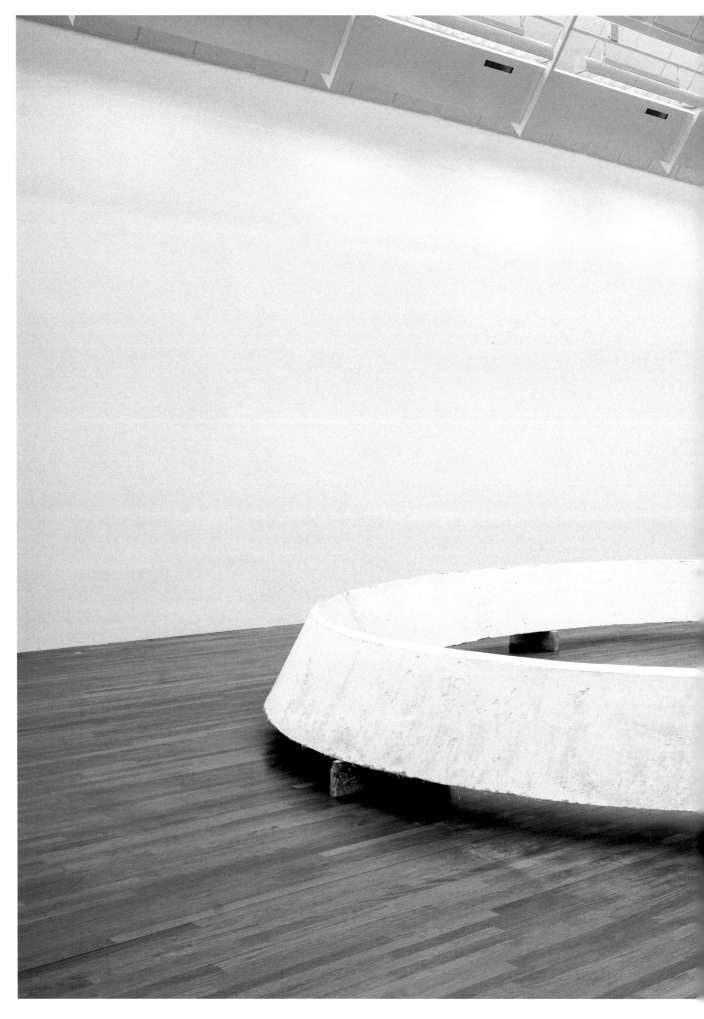

A work by Bruce Nauman
in the Müller building

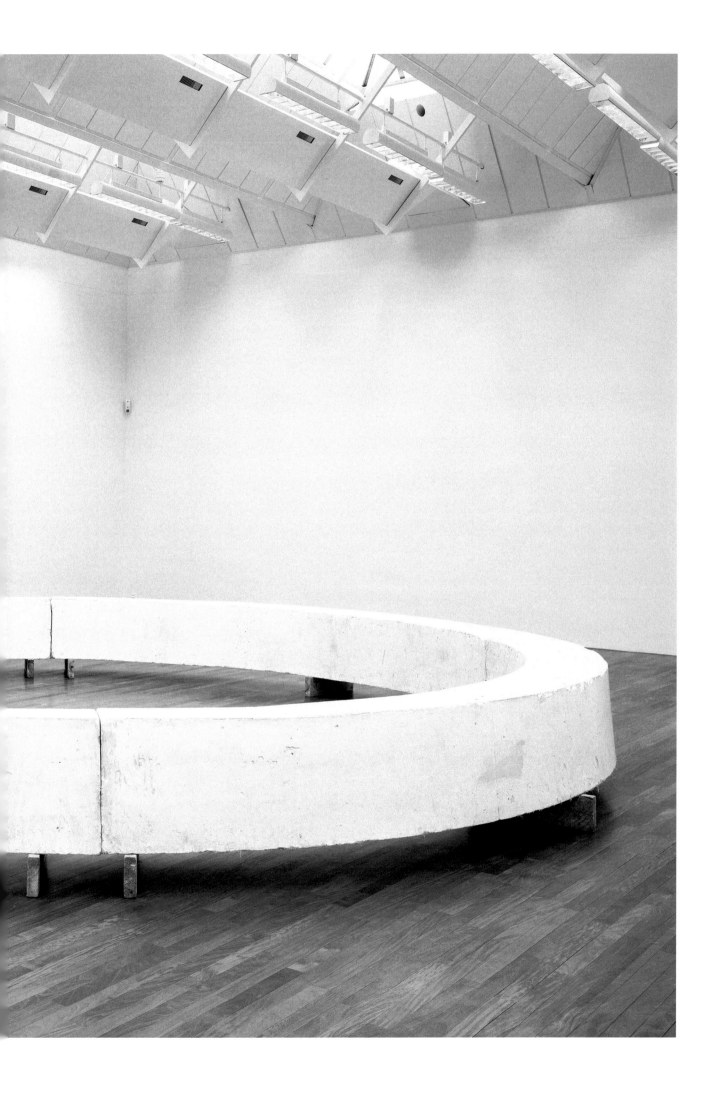

ART AND WAR:
BASELITZ, MUNCH, DENIS

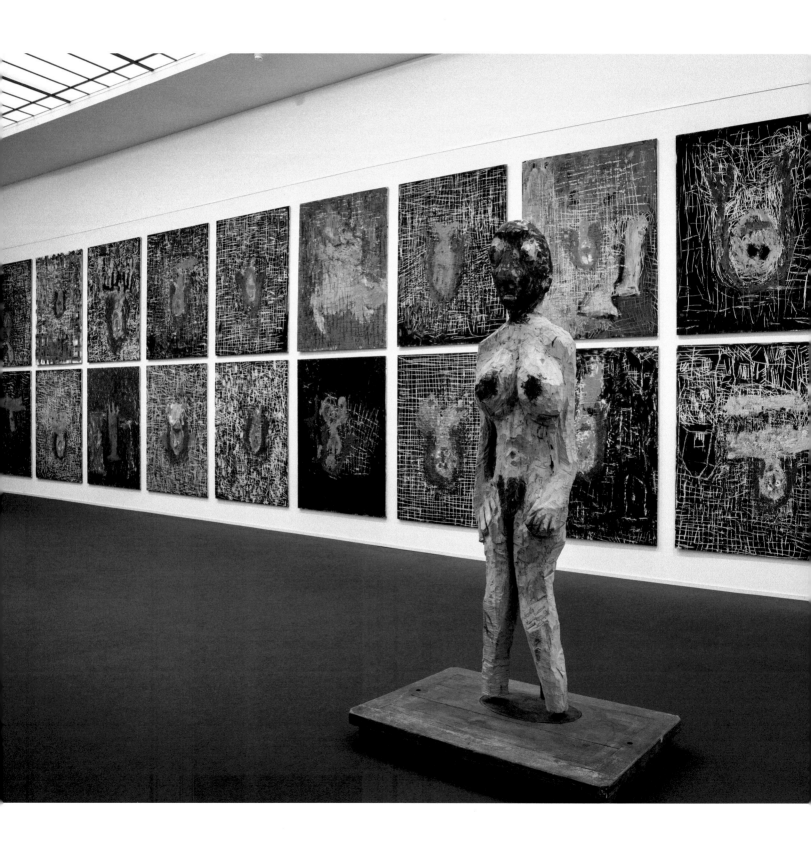

A large room on the second floor of the Moser building is dominated by the works of Edvard Munch (1863–1944) and Georg Baselitz (b. 1938). The latter's monumental, coarsely worked relief series "45", which references the destruction of Dresden in 1945, hangs alongside Marc Chagall's (1887–1985) *The Martyr* from 1940. This picture evokes a pogrom directed at the Jewish population of a Russian town and shows the artist himself as a Christlike figure of suffering. Baselitz's large painting *Supper in Dresden* (1983), suggestive of a riotous feast, depicts the 'Brücke' group of Expressionist artists around Ernst Ludwig Kirchner. The figure in the centre, its mouth wide open, immediately puts us in mind of Edvard Munch's *The Scream*. Munch influenced Baselitz, who is regarded as a pivotal figure in the new Expressionist art, more than the 'Brücke' artists. The paintings from the Kunsthaus's Munch collection, some of which are also linked in a special way to the period of fascism and the Second World War, establish a direct connection between the two artists' works.

Acquisitions in context – provenance research
Linked to these groups of works, an adjoining space examines the contexts in which acquisitions were made during the Nazi period, through two examples from the Kunsthaus's own collection. It sheds light on the Munch paintings from the collection of the Berlin art historian and collector Curt Glaser (1879–1943) which came to Switzerland as flight assets, and on the purchase of two Renoir paintings which arrived at the Kunsthaus from occupied Paris via Galerie Fischer in Lucerne.
Provenance has now become a topic for art itself: an intervention in the centre of the room by the French artist Raphaël Denis (b. 1979) addresses the plundering of Jewish art collections in Paris during the Second World War (see p. 76).

Moser building,
works by Georg Baselitz

Following spread
Moser building,
works by Edvard Munch
and Georg Baselitz

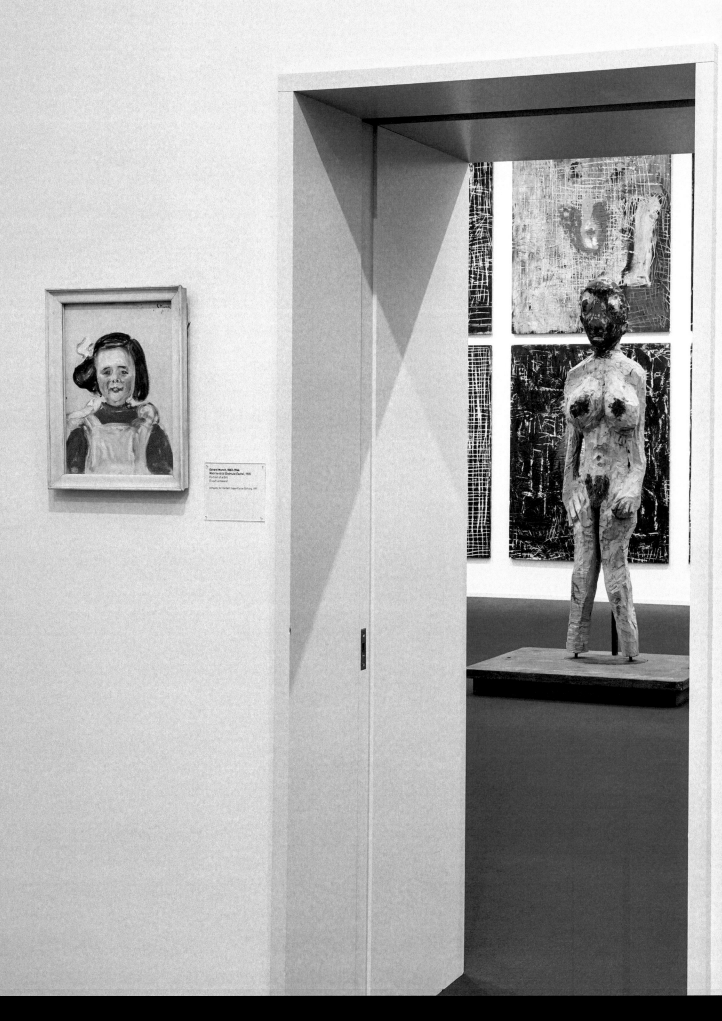

Edvard Munch, 1863–1944
Mädchenbild (Gretmule Esche), 1905
Portrait of a Girl
Öl auf Leinwand

Leihgabe der Herbert Gepp-Karter Stiftung, 1971

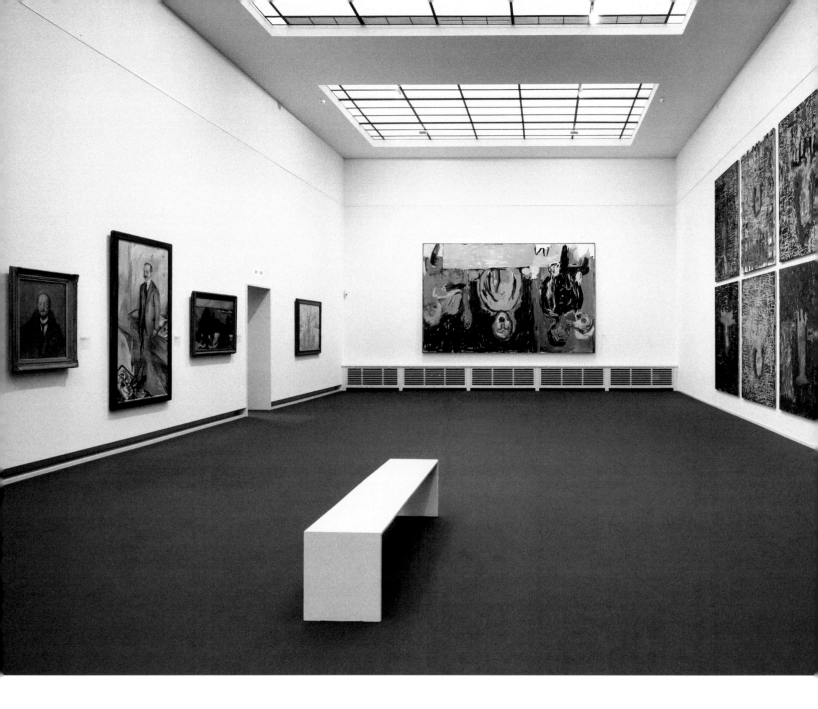

Curt Glaser, Edvard Munch and the Kunsthaus Zürich

Curt Glaser was an art historian of Jewish origin living in Berlin and an important collector, not least of works by Edvard Munch, whom he knew personally. After the first Munch exhibition at the Kunsthaus in 1922, Glaser began an enduring association with the museum's then Director, Wilhelm Wartmann. Following the Nazi seizure of power in Germany in 1933, Glaser and his wife emigrated to Switzerland, and from 1935 they were able, through their connections to Wartmann, to deposit a number of works at the Kunsthaus, including some Munchs. In 1939 Glaser secured the return of Munch's key work *Music on the Karl Johan Street* (1889), which he had donated to Berlin's Nationalgalerie before the Nazis came to power, citing the gallery's failure to display it as agreed, and had it brought on loan to Zurich. Two years later it was acquired by the Kunsthaus when the Glasers moved to the US – finally coming 'to rest in a place worthy of it' as Glaser had wished. In 1943 and 1946, the Kunsthaus acquired three more works from Curt Glaser and Maria Glaser-Ash, his second wife.

Moser building,
works by Edvard Munch
and Georg Baselitz

Renoir for Baselitz – a Franco-German acquisition story
In 1990 the Kunsthaus Zürich decided to sell two paintings by Pierre-Auguste Renoir that were not of central importance to its collection, in order to acquire Georg Baselitz's "45". One of the two Renoirs had been purchased in 1943 via the art dealer Fritz Nathan from Galerie Fischer in Lucerne. Recent research has shown that it was owned by the Jewish art collector Marcel Kapferer (1872–1966) until 1941. The latter had it brought to a place of safety, along with the holdings of Galerie Wildenstein, to keep it out of the clutches of the Nazis. In April 1941 it was returned to Paris by the representative of the 'aryanized' Galerie Wildenstein, Roger Dequoy, and then sold to Galerie Fischer. It has not yet been conclusively established whether he was legally entitled to do this.

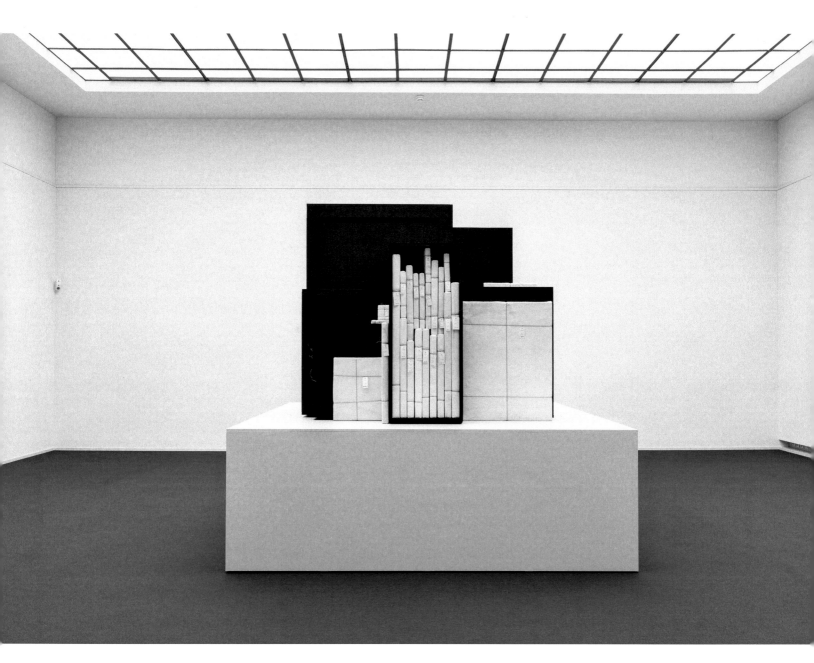

A work by Raphaël Denis
in the Moser building

Provenance as a theme for art: Raphaël Denis
The French artist Raphaël Denis has been working on the theme of looted art for some years. The installation at the Kunsthaus Zürich references the transactions between the art dealer Gustav Rochlitz and Reichsmarschall Hermann Göring after Paris was occupied by the German army in June 1940. Rochlitz had close contacts to the notorious Reichsleiter Rosenberg Taskforce (ERR), an organization set up by the Nazi party to loot cultural property from the countries occupied during the Second World War. Works appropriated from their owners by the ERR were exchanged via Rochlitz for mostly older objects that Hermann Göring wanted for his private collection.

Most of the looted artworks documented here were returned to their former owners after the war. Many ended up in important collections such as the Centre Pompidou in Paris. Four works from the collection of Emil Bührle are also involved: *Irène Cahen d'Anvers (Little Irene)* (1880) by Renoir was returned in 1946; Bührle acquired it in 1949. Bührle was himself obliged to return Degas's *Madame Camus at the Piano* (1869) in 1948. Having acquired it from Galerie Fischer in Lucerne in 1942, he handed it back to its owner and purchased it a second time in 1951. Both works are on display in the Emil Bührle Collection galleries in the extension. 1948 also saw Bührle compelled to return a painting by Henri Matisse, *Odalisque with Tambourine* (1926), which he had purchased in 1942 from Galerie Aktuaryus in Zurich. He did not reacquire this work, and it is now in the Norton Simon Museum in Pasadena, California. Similarly, he did not repurchase Pablo Picasso's painting *At the Races in Auteuil* (1901), which he had bought from Juvet in Lausanne in 1944 and which was returned to its rightful owner Alfred Lindon in 1948.

Joachim Sieber and Philippe Büttner

Moser building,
works by Edvard Munch
and Raphaël Denis

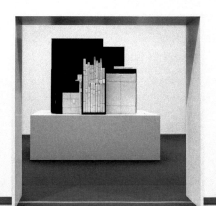

CONTEMPORARY ART

Contemporary art plays a central role in the history of the Kunsthaus Zürich. Unlike other museums that were established by princes or kings, the Kunsthaus owes its foundation to a group of artists. They set up the Künstlergesellschaft in 1787, and from 1794 created the 'painters' books', for which each member donated a drawing each time. Those books are the origin of the Kunsthaus Collection. The idea of linking past and present remained key to the Kunsthaus as time went on. It was a pioneer in staging major exhibitions by contemporary artists, such as Edvard Munch in 1922 and the very first solo show by Pablo Picasso in 1932. More recently, they have been followed by internationally acclaimed artists including Katharina Fritsch, Pipilotti Rist and Cindy Sherman. Most new acquisitions for the collection are of contemporary works, and the extension by Sir David Chipperfield now opens up more space to display them. The result is a multifaceted spectrum of art from the 1960s right through to the latest installations.

Contemporary pieces are mainly displayed on the first floor of the Chipperfield building, but they are also spread around a number of 'intervention spaces' in other areas of the collection and holdings. These spaces host more frequently changing presentations that shed new light on the collection exhibits in the adjoining rooms from a modern-day perspective, sometimes critically interrogating them and complementing existing narratives with current concerns including the postcolonial discourse and, of course, the gender debate. One priority when rearranging the collection was to accord greater prominence to female artists. Judith Bernstein (b.1942), Nathalie Djurberg (b.1978) and Tracey Rose (b.1974) are three examples.

A painting by
Judith Bernstein
(detail) in the
Chipperfield building

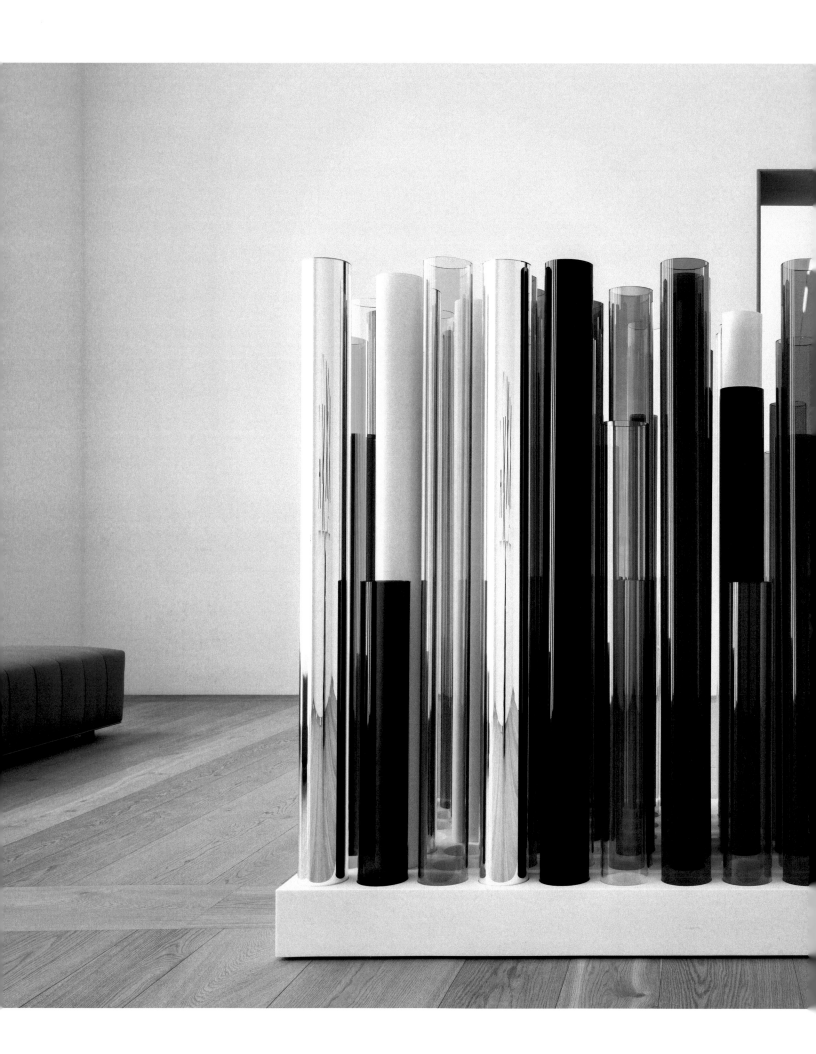

Chipperfield building,
works by Sarah Morris,
Wilhelm Sasnal
and Danh Võ

Following spread
Chipperfield building,
works by Danh Võ

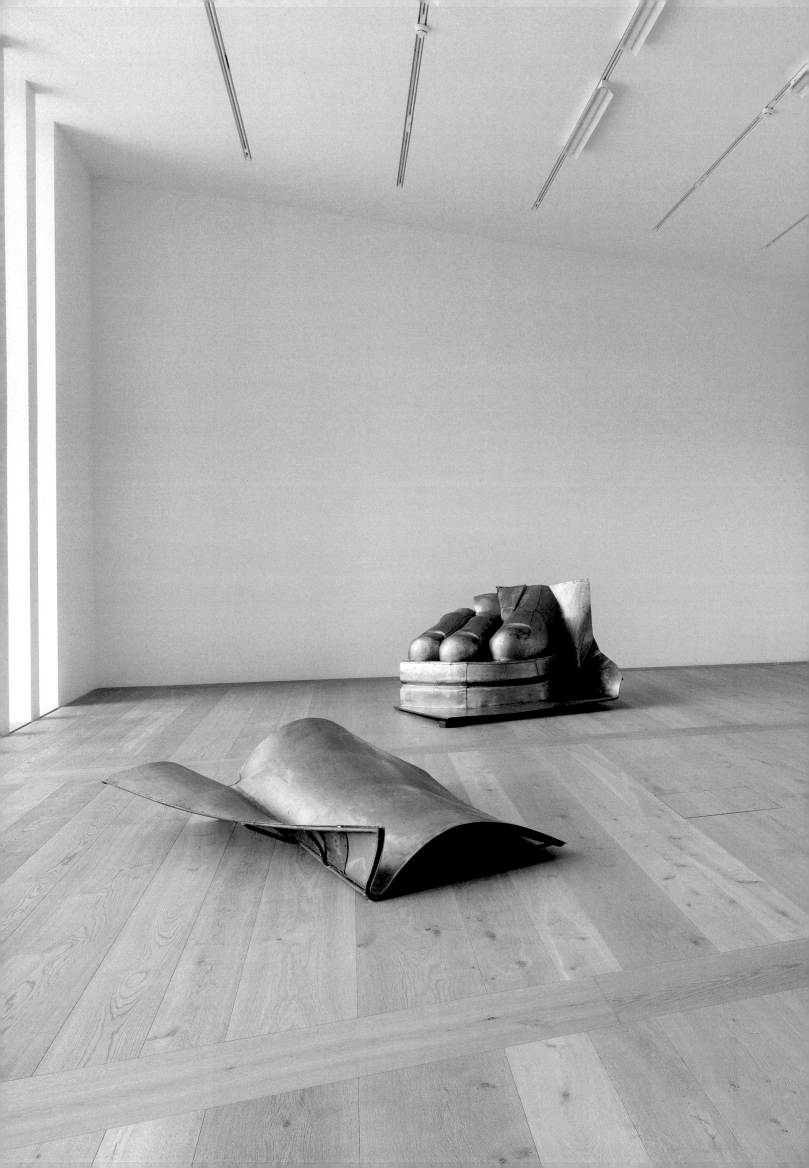

Representing different generations and from widely differing backgrounds, they all share a clearly feminist approach. In *BIRTH OF THE UNIVERSE #2* (2013) Judith Bernstein (now almost eighty years of age) stages an explosive Big Bang, in which two 'angry cunts', as she calls them, take centre stage – with a nod to Gustave Courbet. The work tackles women's rage, but does so with great humour and stylistic devices that can best be described as a kind of comic Expressionism. Nathalie Djurberg employs a similarly crude formal language in her stop-motion video *Turn into Me* (2008). In it, a woman's body – the object of desire through the ages of art history – slowly decomposes and is consumed by maggots and woodland animals. Djurberg's figures are often heavily overdrawn stereotypes that present attributes such as 'race' and 'gender' as constructs projected onto bodies. Finally, Tracey Rose's *A Dream Deferred (Mandela Balls)* (ongoing since 2013) deals with the legacy of Nelson Mandela (1918–2013). The 'balls' are a reference to the problematic situation in her home country of South Africa and the collapse of the ideals that Mandela embodied. The title is taken from a poem by Langston Hughes (1902–1967), a writer of the African-American artist movement Harlem Renaissance, in which he asks if a dream deferred dries up like a raisin in the sun.

A work by Tracey Rose
in the Chipperfield building

Following spread
Chipperfield building,
works by Lungiswa
Gqunta, Teresa Margolles
and Miriam Cahn

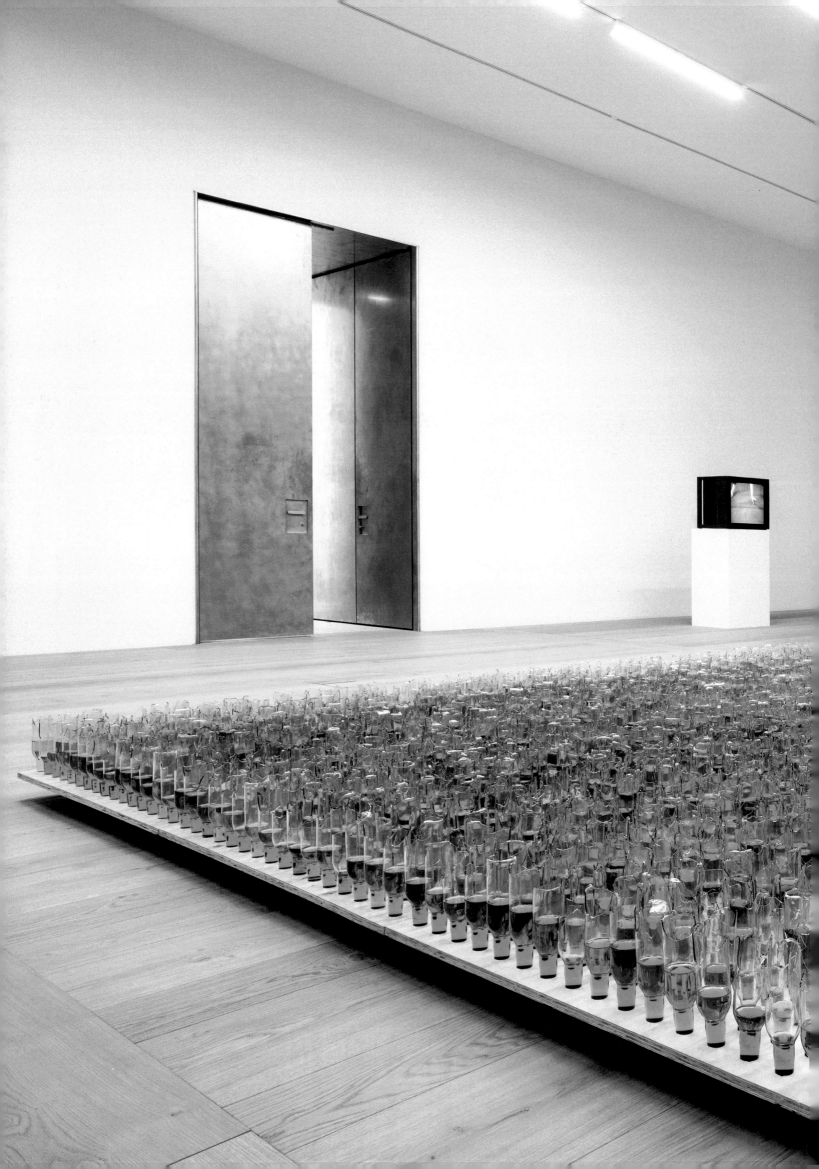

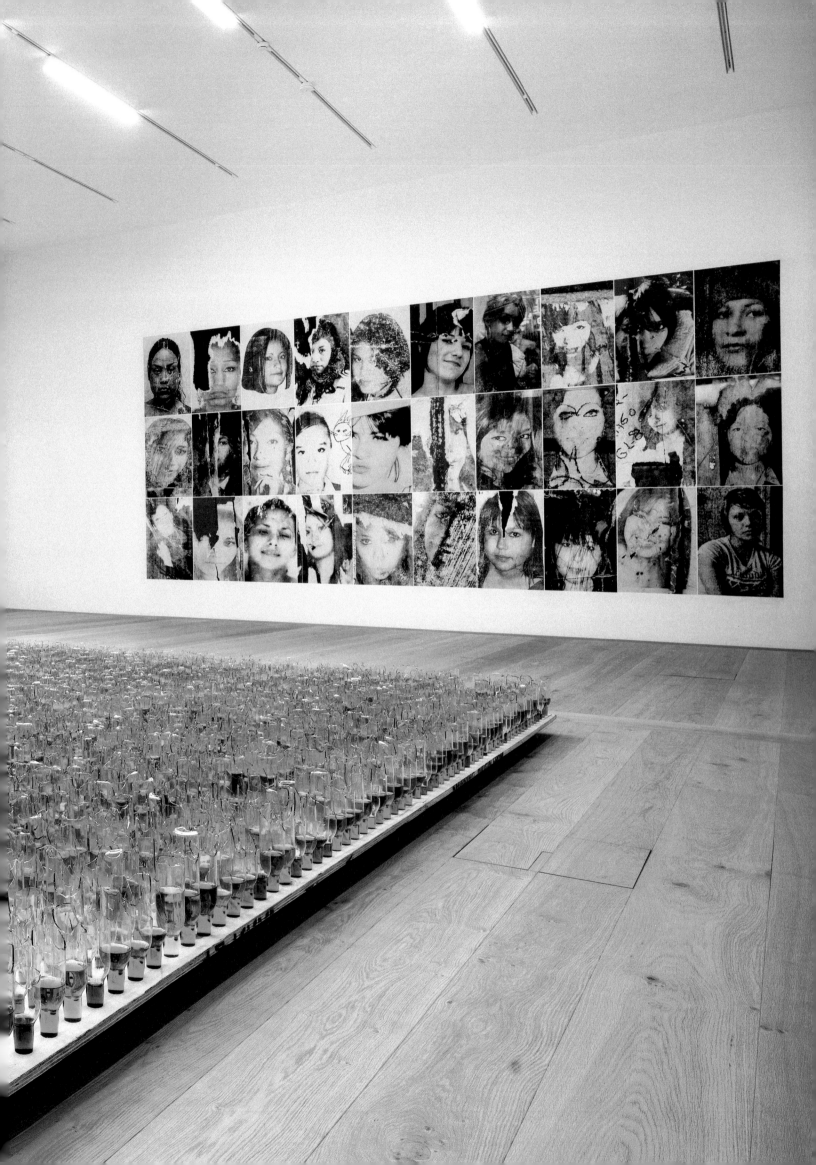

A work by
!Mediengruppe Bitnik
in the Chipperfield building

Also from South Africa is the young artist Lungiswa Gqunta (b. 1990), whose *Lawn* (2017/2019) is displayed on the second floor of the Chipperfield building. The title evokes the manicured green gardens of South Africa's still majority-white upper class; but in Lungiswa Gqunta's installation the lawn consists of broken beer bottles filled with an explosive mixture of petrol and green dye. The artist, who grew up in one of South Africa's biggest townships, thus creates a striking image of marginalization and social injustice with a relevance beyond her own homeland. Immediately adjacent to *Lawn* is the striking mural *Inquiries* (2016) by the Mexican artist Teresa Margolles (b. 1963). It consists of thirty enlarged photographs of missing person notices that Margolles found in Ciudad Juárez in northern Mexico. The border town is notorious for its violence. Since the 1990s, thousands of women there have fallen victim to a mysterious series of murders, most of which have never been solved. In a desperate attempt to find their loved ones, family members stick photos of the missing on walls around the town. Margolles has been interested in the traces those brutal crimes leave on architecture since 2005. Exposed to the weather, the photos gradually fade, and the missing thus vanish a second time. Margolles counters this process by enlarging and condensing the pictures into a powerful memorial denouncing violence against women.

Mirjam Varadinis

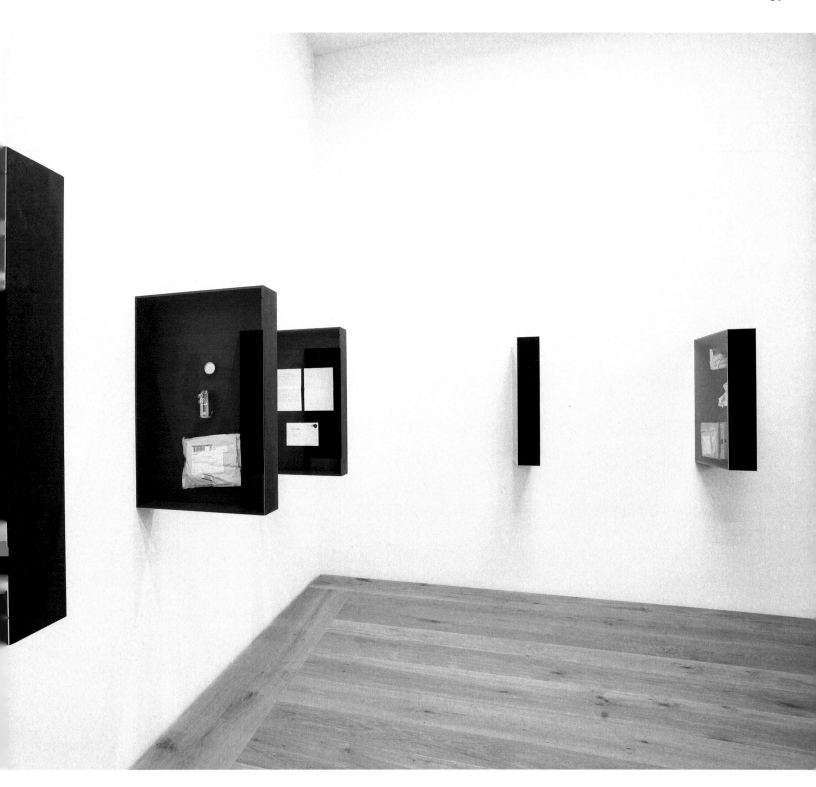

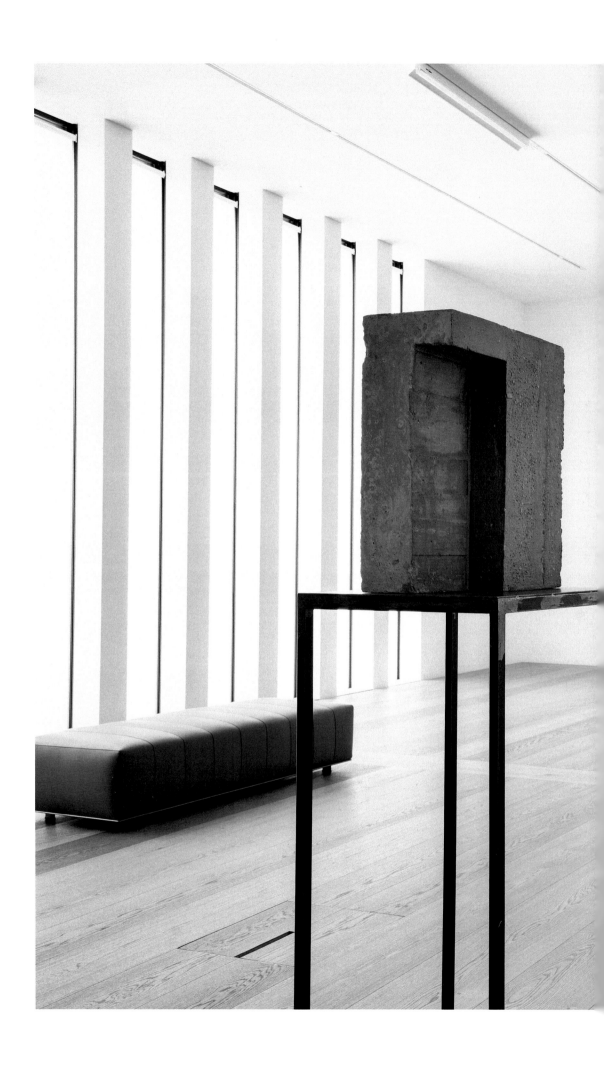

Chipperfield building,
works by Isa Genzken,
Sigmar Polke
and Markus Oehlen

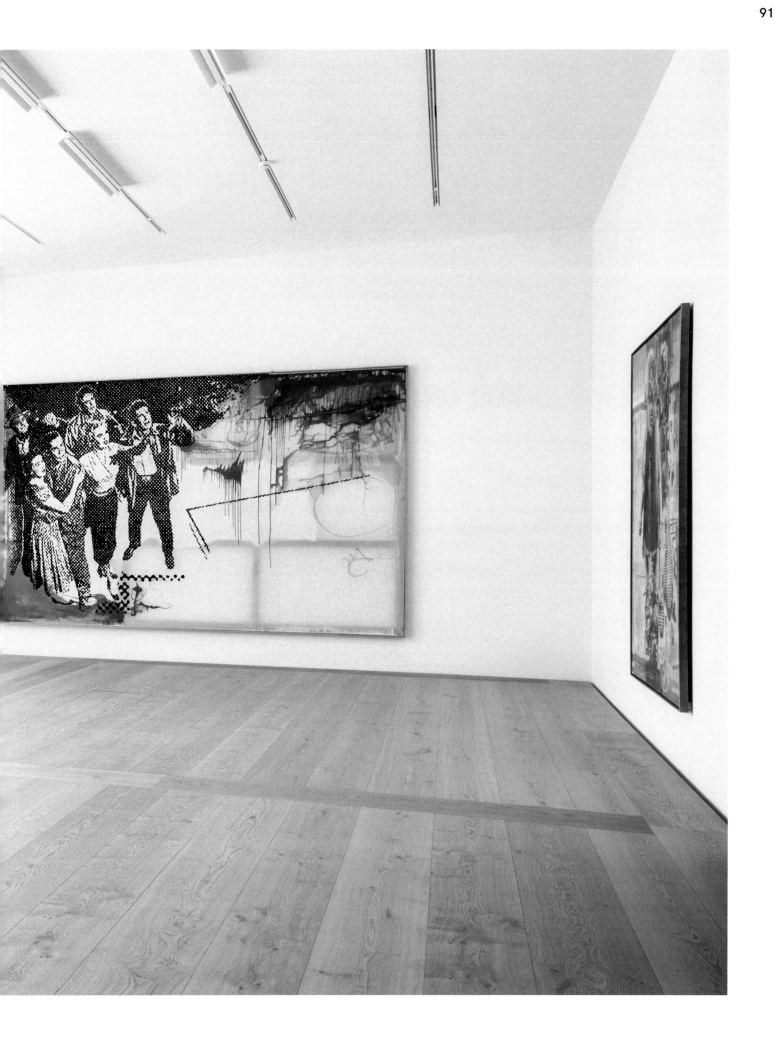

LIST OF DEPICTED WORKS

p. 16
Augusto Giacometti, Phaeton in the Constellation of Scorpio, 1911, Oil on
 canvas, Ø 140 cm, Kunsthaus Zürich, 1917
Auguste Rodin, Orpheus, 1892, Bronze, 145 × 80 × 125 cm, Kunsthaus Zürich,
 1949

p. 17
Ferdinand Hodler, View to Infinity, 1916, Oil on canvas, 343 × 723 cm,
 Kunsthaus Zürich, 1917
Carl Burckhardt, Venus, 1908-09, Coloured marble, 191 × 63 × 69 cm,
 Kunsthaus Zürich, Donated by the Sophie and Karl Binding Foundation,
 2013
Cuno Amiet, Sunspots, 1904, Oil on Eternit, 200 × 120 cm, Kunsthaus Zürich,
 Vereinigung Zürcher Kunstfreunde, 1995

p. 20
Meister der Fürstenbildnisse, Portrait of a Vassal Named Bossaert, 1480-87,
 Oil on panel, 22,5 × 14 cm, Kunsthaus Zürich, Permanent loan from a private
 collection, 2016
 and other works from the same private collection

p. 21 from left to right:
Edgar Degas, Little Dancer Aged Fourteen, 1880-81, Bronze, partially
 painted, cotton skirt, silk ribbon, Height 98 cm, Emil Bührle Collection,
 on permanent loan at Kunsthaus Zürich
Édouard Manet, A Garden Nook at Bellevue, 1880, Oil on canvas, 91 × 70 cm,
 Emil Bührle Collection, on permanent loan at Kunsthaus Zürich
Paul Cézanne, The Boy in the Red Waistcoat, 1888/1890, Oil on canvas,
 79,5 × 64 cm, Emil Bührle Collection, on permanent loan at Kunsthaus
 Zürich
Edgar Degas, Ludovic Lepic and His Daughters, c. 1871, Oil on canvas,
 65 × 81 cm, Emil Bührle Collection, on permanent loan at Kunsthaus Zürich
Paul Cézanne, Madame Cézanne with a Fan, c. 1879/1888, Oil on canvas,
 92,5 × 73 cm, Emil Bührle Collection, on permanent loan at Kunsthaus
 Zürich
Paul Cézanne, Self-Portrait with Palette, c. 1890, Oil on canvas, 92 × 73 cm,
 Emil Bührle Collection, on permanent loan at Kunsthaus Zürich
Vincent van Gogh, Blossoming Chestnut Branches, 1890, Oil on canvas,
 73 × 92 cm, Emil Bührle Collection, on permanent loan at Kunsthaus Zürich
Vincent van Gogh, The Sower with Setting Sun), 1888, Oil on canvas,
 73 × 92 cm, Emil Bührle Collection, on permanent loan at Kunsthaus Zürich

p. 22 from left to right:
Henri Matisse, Interior at Collioure (The Siesta), 1905, Oil on canvas,
 60 × 73 cm, Gabriele and Werner Merzbacher Collection, on permanent
 loan at Kunsthaus Zürich
André Derain, Boats in the Port of Collioure, 1905, Oil on canvas, 72 × 91 cm,
 Gabriele and Werner Merzbacher Collection, on permanent loan at
 Kunsthaus Zürich
André Derain, Tree, Landscape on the River Bank, 1905, Oil on canvas,
 61 × 81 cm, Gabriele and Werner Merzbacher Collection, on permanent
 loan at Kunsthaus Zürich

p. 23
Ellsworth Kelly, White Curve, 2003, Painted aluminium, 75,4 × 442 × 1,9 cm,
 Hubert Looser Foundation, on permanent loan at Kunsthaus Zürich

pp. 26-27
Francis Bacon, Three Studies of the Male Back. Triptych, 1970, Oil on canvas,
 198 × 147,5 cm each, Kunsthaus Zürich, Vereinigung Zürcher Kunstfreunde,
 1982
Rebecca Warren, BB, 2012, Handpainted bronze on painted base,
 211 × 25 × 25 cm, Kunsthaus Zürich, Permanent loan of the Walter
 A. Bechtler Foundation, 2013
Rebecca Warren, La Monte, 2012, Handpainted bronze on painted base,
 218 × 34 × 24 cm, Kunsthaus Zürich, Permanent loan of the Walter
 A. Bechtler Foundation, 2013
Rebecca Warren, August, 2012, Handpainted bronze on painted base,
 219 × 27 × 26 cm, Kunsthaus Zürich, Permanent loan of the Walter
 A. Bechtler Foundation, 2013

pp. 32-33 from left to right:
Alessandro Magnasco, Antonio Francesco Peruzzini, Marco Ricci, Outskirts of
 a Town with Vagrants, c. 1716/1718, Oil on canvas, 231 × 177 cm, Kunsthaus
 Zürich, The Betty and David Koetser Foundation, 1986

Giovanni Lanfranco, Rinaldo's Farewell to Armida, 1614, Oil on canvas,
 109,2 × 178,5 cm, Kunsthaus Zürich, Donated by the Dr. Joseph Scholz
 Foundation and René Wehrli, 2014
Mattia Preti, Christ and the Woman Taken in Adultery, c. 1635/1640, Oil on
 canvas, 145 × 186 cm, Kunsthaus Zürich, The Betty and David Koetser
 Foundation, 1986
Salvator Rosa, Landscape with Pythagoras and the Fishermen, c. 1662, Oil on
 canvas, 123 × 198 cm, Kunsthaus Zürich, The Betty and David Koetser
 Foundation, 1986
Anthony van Dyck, Jan Roos, The Triumph of the Bacchus Child, c. 1626, Oil
 on canvas, 144,5 × 193 cm, Kunsthaus Zürich, The Betty and David Koetser
 Foundation, 1986

pp. 34-35 from left to right:
Johann Heinrich Füssli, The Oath on the Rütli, 1779-81, Oil on canvas,
 267 × 178 cm, Kunsthaus Zürich, Deposited by the Canton of Zurich, 1989
Johann Heinrich Füssli, Cupid and Psyche, c. 1810, Oil on canvas,
 125 × 100 cm, Kunsthaus Zürich, Donated by UBS, 1994
Johann Heinrich Füssli, The Nymphs of the Danube Warn Hagen of the
 Unhappy Outcome of Gunther's Expedition to Krimhild and Etzel,
 1800/1815, Oil on canvas, 118 × 142 cm, Kunsthaus Zürich, Donated by
 Dr. Martin Hürlimann to the City of Zurich, 1978
Johann Heinrich Füssli, Sin, Pursued by Death, 1794-96, Oil on canvas,
 119 × 132 cm, Kunsthaus Zürich, The Gottfried Keller Foundation, Federal
 Office of Culture, Berne, 1926
Johann Heinrich Füssli, Bodmer and Fuseli with a Bust of Homer, 1778-80,
 Oil on canvas, 163 × 150 cm, Kunsthaus Zürich, Donated by Heinrich
 Escher-Escher zum Wollenhof, 1847
Alexander Trippel, Mars and Venus, 1785, Clay, 56 × 40 × 38 cm, Kunsthaus
 Zürich, Bequest of Heinrich Landolt-Mousson, 1918
Johann Heinrich Füssli, Heracles Saves Prometheus from the Eagle,
 1781/1785, Oil on canvas, 63 × 76 cm, Kunsthaus Zürich, Donated by
 Gustav Zumsteg, 1998
Angelica Kauffmann, Portrait of Johann Joachim Winckelmann, 1764, Oil on
 canvas, 97 × 71 cm, Kunsthaus Zürich, Donated by Conrad Zeller, 1850
Angelica Kauffmann, Cupid and Psyche, 1792, Oil on canvas,
 215,5 × 164,5 cm, Kunsthaus Zürich, Donated by the Jacobs Suchard AG,
 Zurich, 1987
Alexander Trippel, Agrippina with the Ashes of Germanicus, 1786, Clay,
 54 × 36 × 37 cm, Kunsthaus Zürich, Bequest of Heinrich Landolt-Mousson,
 1918
Anton Graff, Portrait of the Countess Armfeld with Her Daughter, c. 1793,
 Oil on canvas, 109 × 95 cm, Kunsthaus Zürich, Bequest of Walter Boveri,
 1996
Johann Heinrich Wilhelm Tischbein, Portrait of Johann Jacob Bodmer, 1781,
 Oil on canvas, 80 × 62 cm, Kunsthaus Zürich, Donated by Mayor Johann
 Jakob Escher, 1847

pp. 36-37 from left to right:
Karl Stauffer-Bern, Portrait of Lydia Welti-Escher in a Red Dress, 1886, Oil on
 canvas, 100 × 65 cm, Kunsthaus Zürich, The Gottfried Keller Foundation,
 Federal Office of Culture, Berne, 1892
Karl Stauffer-Bern, Portrait of Gottfried Keller, 1886, Oil on canvas,
 70 × 58,5 cm, Kunsthaus Zürich, The Gottfried Keller Foundation, Federal
 Office of Culture, Berne, 1920
Karl Stauffer-Bern, Portrait of Lydia Welti-Escher, 1886, Oil on canvas,
 150,5 × 100 cm, Kunsthaus Zürich, The Gottfried Keller Foundation, Federal
 Office of Culture, Berne, 1941
Rudolf Koller, First Sketch for 'The Gotthard Post', 1873, Oil on canvas,
 32,5 × 41 cm, Kunsthaus Zürich, The Gottfried Keller Foundation, Federal
 Office of Culture, Berne, 1896
Rudolf Koller, The Gotthard Road, 1873, Oil on canvas, 54 × 65 cm, Kunsthaus
 Zürich, 1905

p. 39
Jan Asselijn, Harbour Scene with Galley Slaves, c. 1652, Oil on canvas,
 49,5 × 42,5 cm, Kunsthaus Zürich, The Ruzicka Foundation, 1948 (detail)

pp. 40-41 from left to right:
Jan Davidsz. de Heem, Still Life with Epigram and Lenten Food, c. 1650, Oil on
 canvas, 42,5 × 56,5 cm, Kunsthaus Zürich, The Betty and David Koetser
 Foundation, 1986
Jan Asselijn, Harbour Scene with Galley Slaves, c. 1652, Oil on canvas,
 49,5 × 42,5 cm, Kunsthaus Zürich, The Ruzicka Foundation, 1948
Kader Attia, Culture, Another Nature Repaired, 2014, Teak wood on metal
 stand, 75 × 41,7 × 37 cm / 126 × 46 × 46 cm, Kunsthaus Zürich, 2015
Anna Boghiguian, Untitled, 2018, Tempera, acrylic and graphite on fabric,
 1071 × 694 × 2,5 cm, Kunsthaus Zürich, 2018 (detail)
Willem van de Velde (II), A Calm: A States Yacht, Sailing and Fishing Boats
 near the Shore, c. 1660, Oil on canvas, 55 × 63 cm, Kunsthaus Zürich,
 The Betty and David Koetser Foundation, 1986
Jan van de Cappelle, Boats on the Mouth of the Scheldt, 1651, Oil on canvas,
 66 × 97 cm, Kunsthaus Zürich, The Ruzicka Foundation

pp. 42–43
Kader Attia, Culture, Another Nature Repaired, 2014, Teak wood on metal
 stand, 75 × 41,7 × 37 cm / 126 × 46 × 46 cm, Kunsthaus Zürich, 2015
Anna Boghiguian, Untitled, 2018, Tempera, acrylic and graphite on fabric,
 1071 × 694 × 2,5 cm, Kunsthaus Zürich, 2018

pp. 44–45 from left to right:
Claude Monet, The Water Lily Pond in the Evening, 1916/1922, Oil on canvas,
 200 × 600 cm, Kunsthaus Zürich, Donated by Emil G. Bührle, 1952
Claude Monet, The Water Lily Pond with Irises, 1914/1922, Oil on canvas,
 200 × 600 cm, Kunsthaus Zürich, Donated by Emil G. Bührle, 1952

pp. 46–47 from left to right:
Claude Monet, The Water Lily Pond in the Evening, 1916/1922, Oil on canvas,
 200 × 600 cm, Kunsthaus Zürich, Donated by Emil G. Bührle, 1952
Camille Pissarro, The Big Pear Tree at Montfoucault, 1876, Oil on canvas,
 54 × 65 cm, Kunsthaus Zürich, Johanna and Walter L. Wolf Collection, 1984
Claude Monet, The Cliff at Dieppe, 1882, Oil on canvas, 66 × 82 cm, Kunsthaus
 Zürich, Vereinigung Zürcher Kunstfreunde, 1932
Auguste Rodin, The Age of Bronze, 1875–76, Bronze, 179 × 67 × 62 cm,
 Kunsthaus Zürich, 1935
Alfred Sisley, The Road, 1885, Oil on canvas, 65 × 92 cm, Kunsthaus Zürich,
 Donated by Ms. Marguerite Abraham in memory of her husband Ludwig
 Abraham, 2002
Claude Monet, Houses of Parliament, Sunset, 1904, Oil on canvas, 81 × 92 cm,
 Kunsthaus Zürich, Donated by Walter Haefner, 1995
Claude Monet, Grainstack in Sunlight, 1891, Oil on canvas, 60 × 100 cm,
 Kunsthaus Zürich, Purchased with funds from the Otto Meister Bequest, 1969

pp. 48–49 from left to right:
Pablo Picasso, Head of a Woman (Fernande), 1909, Bronze,
 41 × 24,5 × 25,5 cm, Kunsthaus Zürich, 1944
Fernand Léger, The Stairway, 1913, Oil on canvas, 144 × 118 cm, Kunsthaus
 Zürich, 1933
Pablo Picasso, Big Nude, 1964, Oil on canvas, 140 × 195 cm, Kunsthaus Zürich,
 1969

pp. 50–51 from left to right:
Ferdinand Hodler, Lake Silvaplana in Autumn, 1907, Oil on canvas,
 71 × 92,5 cm, Kunsthaus Zürich, Bequest of Richard and Miss Mathilde
 Schwarzenbach, 1920
Ferdinand Hodler, Portrait of Valentine Godé-Darel, c. 1912, Oil on canvas,
 43 × 33 cm, Kunsthaus Zürich, Vereinigung Zürcher Kunstfreunde, 1917
Ferdinand Hodler, Lake Geneva from Chexbres, c. 1905, Oil on canvas,
 95,5 × 104.5 cm, Kunsthaus Zürich, Bequest of Richard and Miss Mathilde
 Schwarzenbach, 1920
Ferdinand Hodler, Self-Portrait, 1916, Oil on canvas, 61 × 53 cm, Kunsthaus
 Zürich, Vereinigung Zürcher Kunstfreunde, 1917
Alice Bailly, Woman in a Mirror, 1918, Oil on canvas, 50 × 61 cm, Dr. H. E.
 Mayenfisch Collection, 1929
Ferdinand Hodler, Song from Afar, c. 1914, später überarbeitet, Oil on canvas,
 180 × 129 cm, Kunsthaus Zürich, Donated by Alfred Rütschi, 1919

P. 52–53 from left to right:
Ferdinand Hodler, Lake Geneva with the Mont Blanc in the Early Morning,
 1918, Oil on canvas, 65 × 91,5 cm, Kunsthaus Zürich, Donated by the
 Holenia Trust in memory of Joseph H. Hirshhorn, 1992
Ferdinand Hodler, Forest Brook near Leissigen, 1904, Oil on canvas,
 88,5 × 101,5 cm, Kunsthaus Zürich, Bequest of Richard Schwarzenbach,
 1920
Giovanni Segantini, Alpine Pastures, 1893–94, Oil on canvas, 169 × 278 cm,
 Kunsthaus Zürich, 1985
Giovanni Segantini, Knitting Girl, 1888, Oil on canvas, 53 × 91,5 cm,
 Kunsthaus Zürich, The Gottfried Keller Foundation, Federal Office of
 Culture, Berne, 1909
Auguste Rodin, Jean d'Aire (Great Nude Study for 'The Burghers of Calais'),
 1887, Bronze, 205 × 68 × 67 cm, Kunsthaus Zürich, Permanent loan of the
 Canton of Zurich, 1949, Restored with support of the Bank of America Art
 Conservation Project
Giovanni Segantini, Vanity, 1897, Oil on canvas, 77 × 124 cm, Kunsthaus
 Zürich, Purchased with a contribution from the UBS, 1996

p. 55 from left to right:
Francis Bacon, Figure in Mountain Landscape, 1956, Oil on canvas,
 152 × 119 cm, Kunsthaus Zürich, 1983
Alberto Giacometti, Dog, 1951, Bronze, 46 × 98,5 × 15 cm, Kunsthaus Zürich,
 Alberto Giacometti-Stiftung, 1965
Alberto Giacometti, The Chariot, 1950, Bronze, patinated in gold tone, on
 black painted wooden bases, 167 × 69 × 69 cm, Kunsthaus Zürich, Alberto
 Giacometti-Stiftung, 1965
Nicolas de Staël, Composition, 1951, Oil on canvas, 160 × 75 cm, Kunsthaus
 Zürich, 1952

Alberto Giacometti, Large Head of Diego, 1954, Bronze, 65 × 39,5 × 24,5 cm,
 Kunsthaus Zürich, Alberto Giacometti-Stiftung, 1965
Alberto Giacometti, Annette, 1951, Oil on canvas, 81 × 65 cm, Kunsthaus
 Zürich, Alberto Giacometti-Stiftung, 1965
Alberto Giacometti, The Cage (Woman and Head), 1950, Bronze, painted,
 178 × 39,5 × 38,5 cm, Kunsthaus Zürich, Alberto Giacometti-Stiftung, 1965
Alberto Giacometti, Four Figurines on a Stand, 1950, Bronze, patinated in
 gold tone, figures painted, 162 × 41,5 × 32 cm, Kunsthaus Zürich, Alberto
 Giacometti-Stiftung, 1965

pp. 56–57 from left to right:
Alberto Giacometti, Cube, 1933–34, Plaster, painted white, 95 × 54 × 59 cm,
 Kunsthaus Zürich, Alberto Giacometti-Stiftung, Donated by Bruno and
 Odette Giacometti, 2006
Alberto Giacometti, Spoon Woman, 1926–27, Bronze, 144 × 51 × 23 cm,
 Kunsthaus Zürich, Alberto Giacometti-Stiftung, 1965
Meret Oppenheim, Masked Flower, 1958, Wood painted with rootstock,
 108 × 54 × 40 cm, Kunsthaus Zürich, 1973
Constantin Brancusi, Sleeping Muse II, c. 1925, Polished bronze,
 17 × 27 × 17 cm, Kunsthaus Zürich, Bequest of Heinz Keller, 1984
Max Ernst, Untitled (Carved Stone), 1935, Granite, 18 × 33 × 30 cm, Kunsthaus
 Zürich, Vereinigung Zürcher Kunstfreunde, Donated by Bruno and Odette
 Giacometti, 2006
Alberto Giacometti, Cube, 1933–34, Bronze, 95 × 54 × 59 cm, Kunsthaus
 Zürich, Alberto Giacometti-Stiftung, 1965

pp. 58–59 from left to right:
Jackson Pollock, Number 21, 1951, Synthetic resin on canvas, 145 × 94 cm,
 Kunsthaus Zürich, Donated by the Holenia Trust in memory of Joseph
 H. Hirshhorn, 1988
Sonja Sekula, Silence, 1951, Oil on canvas, 147 × 101 cm, Kunsthaus Zürich,
 Donated by the artist's mother, 1966
Jackson Pollock, Untitled (Composition with Sgraffito II), c. 1944, Oil on
 canvas, 46,6 × 35,5 cm, Kunsthaus Zürich, Acquired with a contribution from
 the Kunststiftung and the Hulda and Gustav Zumsteg Foundation, 2013
Mark Rothko, Untitled (White, Blacks, Grays on Maroon), 1963, Oil on canvas,
 227 × 175 cm, Kunsthaus Zürich, 1971

p. 60 from left to right:
Cy Twombly, Untitled. Rome, 1983, Wood, plaster, nails, plasticine and matt
 oil-based wall paint, 198 × 158 × 36 cm, Kunsthaus Zürich, 1994
Cy Twombly, Vengeance of Achilles, 1962, Oil, chalk and lead pencil on
 canvas, 300 × 175 cm, Kunsthaus Zürich, 1987
Cy Twombly, Untitled. Rome, 1978, Wood, nails and oil-based wall paint,
 23 × 52 × 33 cm, Kunsthaus Zürich, 1994
Cy Twombly, Untitled. Rome, 1959, Cardboard, wood, and fabric, painted
 with synthetic resin, 67 × 34 × 27 cm, Kunsthaus Zürich, 1994

p. 61 from left to right:
Cy Twombly, Winter's Passage: Luxor. Porto Ercole, 1985, Wood, nails, white
 paint; pencil on paper, 53,5 × 105 × 51 cm, Kunsthaus Zürich, 1994
Cy Twombly, Rotalla. Gaeta, 1986, Wood and sheet iron, iron, cloth tape,
 painted, 72 × 71 × 52 cm, Kunsthaus Zürich, 1994

p. 62 from left to right:
Sylvie Fleury, The Eye of the Vampire (violet), 2015, Fiberglass cast,
 polyurethane paint, 140 × 139 × 82 cm, Kunsthaus Zürich, Courtesy of the
 artist and Karma International, Zürich
Sylvie Fleury, 400 Pontiac, 1999, Chromed bronze, 70 × 58 × 76 cm, Kunsthaus
 Zürich, Courtesy of the artist and Karma International, Zürich
Sylvie Fleury, 283 Chevy, 1999, Chromed bronze, 71 × 45 × 70 cm, Kunsthaus
 Zürich, Courtesy of the artist and Karma International, Zürich
Sylvie Fleury, 383 Mopar Special Police, 1999, Chromed bronze,
 73 × 60 × 68 cm, Kunsthaus Zürich, Courtesy of the artist and Karma
 International, Zürich
Sylvie Fleury, The Eye of the Vampire (yellow), 2015, Fiberglass cast,
 polyurethane paint, 138 × 140 × 80 cm, Kunsthaus Zürich, Courtesy of the
 artist and Karma International, Zürich

p. 63 from left to right:
Andy Warhol, Big Torn Campbell's Soup Can (Vegetable Beef), 1962, Casein,
 gold paint and pencil on canvas, 183 × 137 cm, Kunsthaus Zürich, 1975
Roy Lichtenstein, Yellow Brushstroke, 1965, Oil and Magna on canvas,
 173 × 142 cm, Kunsthaus Zürich, 1975
Abraham Cruzvillegas, Autokonßtrukschön #1, 2018, Wood, glass, metal,
 plastic, tissue, 260 × 70 × 110 cm, Kunsthaus Zürich, 2018
Robert Rauschenberg, Overdraw (untitled), 1963, Oil and serigraphy on
 canvas, 152,2 × 305 cm, Kunsthaus Zürich, 1972
Roy Lichtenstein, Baked Potato, 1962, Acryl auf Leinwand, 61 × 91,5 cm,
 Kunsthaus Zürich, Erna and Curt Burgauer Collection, 1976

p. 64
Jean Tinguely, Cycloengraver, 1960, Welded scrap iron, bicycle parts, metal
plate, drum, cymbal, and telephone book, 225 × 110 × 410 cm, Kunsthaus
Zürich, Donated by the artist, 1986

p. 66
Jenny Holzer, Selections from Truisms, 1984, Neon sign box, 14 × 77,5 × 13 cm,
Kunsthaus Zürich, Vereinigung Zürcher Kunstfreunde, Gruppe Junge Kunst,
1985

pp. 68–69
Bruce Nauman, Model for Tunnel. Square to Triangle, 1981, Plaster, wood and
metal, Height 68 cm, Ø 665 cm, Kunsthaus Zürich, 1981

pp. 70–71
Georg Baselitz, Greetings from Oslo, 1986, Limewood, oil and charcoal; Iron
girder on painted wooden panel, 247 × 138,5 × 89 cm, Kunsthaus Zürich,
1989
Georg Baselitz, «45», 1989, Tempera and oil on glued plywood, worked with
a plane, 20 panels, 200 × 162 cm each, Kunsthaus Zürich, 1990

pp. 72–73 from left to right:
Edvard Munch, Portrait of a Girl (Erdmute Esche), 1905, Oil on canvas,
41 × 32 cm, Kunsthaus Zürich, Loan of the Herbert Eugen Esche Foundation,
1997
Georg Baselitz, Greetings from Oslo, 1986, Limewood, oil and charcoal;
Iron girder on painted wooden panel, 247 × 138,5 × 89 cm, Kunsthaus Zürich,
1989
Georg Baselitz, «45», 1989, Tempera and oil on glued plywood, worked with
a plane, 20 panels, 200 × 162 cm each, Kunsthaus Zürich, 1990 (detail)
Edvard Munch, Portrait of Herbert Esche, 1905, Oil on canvas, 71 × 55,5 cm,
Kunsthaus Zürich, Loan of the Herbert Eugen Esche Foundation, 1997

pp. 74–75 from left to right:
Edvard Munch, Portrait of Albert Kollmann, c. 1901-02, Oil on canvas,
81,5 × 66 cm, Kunsthaus Zürich, 1943
Edvard Munch, Portrait of Dr. Wilhelm Wartmann, 1923, Oil on canvas,
200 × 111 cm, Kunsthaus Zürich, Donated by Alfred Rütschi, 1929
Edvard Munch, Winter Night, c. 1900, Oil on canvas, 81 × 121 cm, Kunsthaus
Zürich, 1931
Edvard Munch, Apple Tree, 1921, Oil on canvas, 100 × 130,5 cm, Kunsthaus
Zürich, Donated by Alfred Rütschi, 1929
Georg Baselitz, Supper in Dresden, 1983, Oil on canvas, 280 × 450 cm,
Kunsthaus Zürich, 1991
Georg Baselitz, «45», 1989, Tempera and oil on glued plywood, worked with
a plane, 20 panels, 200× 162 cm each, Kunsthaus Zürich, 1990 (detail)

p. 76
Raphaël Denis, The Normal Distribution of Errors: The Göring – Rochlitz
Transactions, 2021, Wood, fabric, string, Variable sizes, Kunsthaus Zürich,
2021

p. 77 from left to right:
Edvard Munch, Portrait of Else Glaser, 1913, Oil on canvas, 120,5 × 85 cm,
Kunsthaus Zürich, 1946
Edvard Munch, Music on the Karl Johan Street, 1889, Oil on canvas,
101,5 × 140,5 cm, Kunsthaus Zürich, 1941
Raphaël Denis, The Normal Distribution of Errors: The Göring – Rochlitz
Transactions, 2021, Wood, fabric, string, Variable sizes, Kunsthaus Zürich,
2021
Edvard Munch, Portrait of Albert Kollmann, c. 1901-02, Oil on canvas,
81,5 × 66 cm, Kunsthaus Zürich, 1943
Edvard Munch, Portrait of Dr. Wilhelm Wartmann, 1923, Oil on canvas,
200 × 111 cm, Kunsthaus Zürich, Donated by Alfred Rütschi, 1929

p. 79
Judith Bernstein, BIRTH OF THE UNIVERSE #2, 2013, Oil on canvas,
240 × 242 cm, Kunsthaus Zürich, 2020 (detail)

pp. 80–81 from left to right:
Sarah Morris, What can be explained can also be predicted, 2019, Lacquered
glass, marble, 160 × 135 × 105 cm, Kunsthaus Zürich, Donated by Cristina
and Thomas W. Bechtler in memory of their daughter Johanna Bechtler,
2019
Danh Võ, We The People, 2011–2016, Copper, 50 × 206 × 171 cm (element
#J8.2), 213 × 359 × 96 cm (element #J11), 184 × 306 × 158 cm (element
#O2.1.2), 124 × 247 × 190 cm (element #A 10.1.1), Kunsthaus Zürich,
Erworben mit Unterstützung der Swiss Re – Partner für zeitgenössische
Kunst, 2014 (detail)
Wilhelm Sasnal, mpec, 2005, Oil on cotton, 80 × 60 cm, Kunsthaus Zürich,
2005

pp. 82–83
Danh Võ, We The People, 2011–2016, Copper, 50 × 206 × 171 cm (element
#J8.2), 213 × 359 × 96 cm (element #J11), 184 × 306 × 158 cm (element
#O2.1.2), 124 × 247 × 190 cm (element #A 10.1.1), Kunsthaus Zürich,
Erworben mit Unterstützung der Swiss Re – Partner für zeitgenössische
Kunst, 2014
Danh Võ, «Aconitum souliei, Inflorescence portion / Lilium souliei, outer and
inner tepel / Anemone coelestina var. souliei, flowering plant / Rosa
soulieana, fruit / Aconitum souliei, cauline leaf / Anemone coelestina, basal
leaf / Anemone coelestina, carpel / Luzula rufescens, flowering plant /
Anconitum souliei, upper cauline leaf / Anemone coelestina, basal leaf /
Anemone coelestina, flowering plant / Rosa soulieana, fruiting branch /
Lilium souliei, distal portion of flowering plant / Nepeta souliei, flowering
plant / Rosa soulieana, flowering branch / Cerasus fruticosa, fruiting
branch / Cerasus tomentosa var. souliei, fruiting branch», Wallpaper, 2009,
Variable sizes, Kunsthaus Zürich, on permanent loan of the Raeber families

p. 84
Tracey Rose, A Dream Deferred (Mandela Balls), 2013 ongoing, Mixed media,
Variable sizes, Kunsthaus Zürich, 2018

pp. 86–87
Lungiswa Gqunta, Lawn, 2017/2019, Glass, wood, paint, petrol, 336 × 483 cm,
Kunsthaus Zürich, Vereinigung Zürcher Kunstfreunde, Gruppe Junge Kunst,
2019
Teresa Margolles, Inquiries, 2016, Installation, 30 color prints of photographs
of street signs showing missing women that cover the walls of Ciudad
Juárez, Mexico, from the nineties until today, 100 × 70 cm each, total:
301 × 704,5 cm, Kunsthaus Zürich, Collection of Photography, 2017
Miriam Cahn, The Wild Loving: Female Weapons – Missiles – Falsified
Weapons, 1984, 1-channel video, b/w, sound; acquired as U-matic S, PAL,
4:3, duration: 9' 30'', Kunsthaus Zürich, Video Collection, 1984

pp. 88–89
!Mediengruppe Bitnik, Random Darknet Shopper: Live Edition (St. Gallen),
2014–2016, 12 Custom Display Cases, (90,5 × 60 × 15 cm each), Bot Lap
Top, Kunsthaus Zürich, Property of the Swiss Confederation, Federal Office
of Culture, Berne, 2021

pp. 90–91 from left to right:
Isa Genzken, TV, 1986, Concret on steel column plate, 197 × 58 × 49 cm,
Kunsthaus Zürich, 2013
Sigmar Polke, Levitation, 2005, Synthetic resin on gauze on textured fabric,
300 × 500 cm, Kunsthaus Zürich, Vereinigung Zürcher Kunstfreunde, 2005
Markus Oehlen, Untitled, 2008, Mixed media on canvas, 250 × 200 cm,
Kunsthaus Zürich, 2017

IMPRINT

Edited by: Zürcher Kunstgesellschaft / Kunsthaus Zürich
Concept: Philippe Büttner
Texts: Christoph Becker, Philippe Büttner, Joachim Sieber, Mirjam Varadinis
Translations: Geoffrey Spearing
Content editing: Franziska Lentzsch, Eva Dewes
Copy editing: Franziska Lentzsch, Colette Forder
Visual concept and typesetting: Katarina Lang, Kezia Stingelin, Zurich
Photographs: Franca Candrian; Luxwerk, Zurich (Drone shot pp. 6–7)
Typefaces: Dazzle Unicase, GT Walsheim, Centennial
Paper: LuxoArt Samt
Printing and binding: DZA Druckerei zu Altenburg GmbH, Thuringia

Verlag Scheidegger & Spiess
Niederdorfstrasse 54
8001 Zurich
Switzerland
www.scheidegger-spiess.ch

Scheidegger & Spiess is being supported by the Federal Office of Culture with a general subsidy for the years 2021–2024.

ISBN 978-3-03942-059-9